LITTLE BOOK OF

PRADA

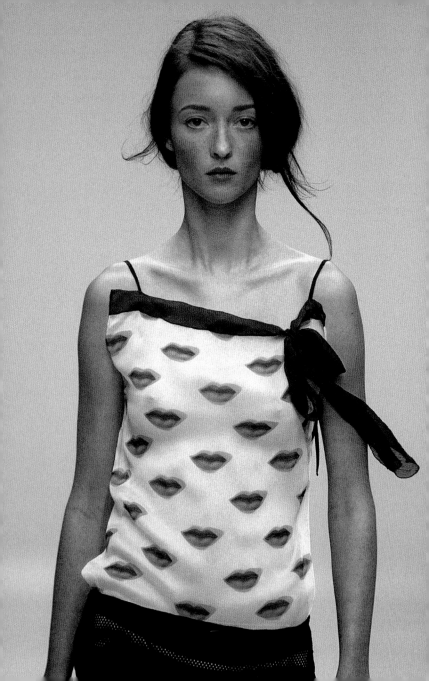

LITTLE BOOK OF

PRADA

LAIA FARRAN GRAVES

WELBECK

A stylist and journalist specializing in fashion and beauty, **Laia Farran Graves** has also worked for such publications as *Vogue, InStyle, Glamour, Marie Claire* and *The Sunday Times Style* magazine. Laia lives in London.

To Lucia

First published in 2012 and 2017 by Carlton Books Limited

This edition published in 2020 by Welbeck
An Imprint of HEADLINE PUBLISHING GROUP

41

Cataloguing in Publication Data is available from the British Library

ISBN 978 1 78739 459 9

Printed in China

MIX
Paper | Supporting responsible forestry
FSC
www.fsc.org
FSC® C104740

HEADLINE PUBLISHING GROUP
An Hachette UK Company, Carmelite House
50 Victoria Embankment, London EC4Y 0DZ

www.headline.co.uk
www.hachette.co.uk

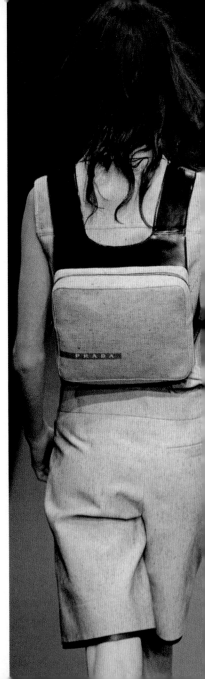

Contents

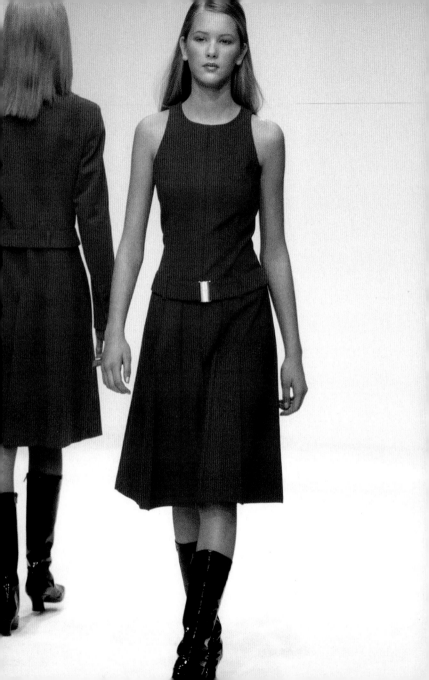

Introduction

The following pages tell the extraordinary story of Prada – a Milanese brand that began as a luxury leather goods company and was transformed into a multinational empire after the founder's granddaughter, Miuccia Prada, took over in 1978. This book explores Prada's visionary philosophy, along with the meteoric rise of the company and the global appeal of the label.

The first chapters consider Prada's aesthetic development, from the early accessories collections that culminated in the nylon tote in 1985 that changed the face of luxury accessories, to the most striking prêt-à-porter collections of recent times. We take a close look at key elements, highlighting the experimental and innovative way in which texture, fabrics and colour are used as a means to challenge our preconceptions of beauty.

Documenting Prada's crucial part in minimalism in its early years, this book reviews the company's progression and looks at the crucial role it played in the later return to femininity, strongly influenced by the silhouettes of the 1940s, 1950s and 1960s. At the same time, the ethos of the brand – a constant fusion of traditional values and techniques with ground-breaking modern ideas – is explored.

A chapter also discusses Miu Miu, Prada's diffusion line, and tracks its journey from the time when it first showed in Milan to the bold move to Paris Fashion Week in a quest to redefine itself in its own right. More recent collections are discussed and the essence of this quirky brand is outlined. Prada Men also features in a chapter that explores the label's menswear success and its own unique style. Other areas of the brand's involvement, such as the beauty industry, are also touched upon. The final section of the book highlights Prada's impressive engagement in the arts through the non-profit making Fondazione Prada, exciting plans for the future are unveiled and attention is focused on the unique contribution the company has made, and continues to make, to the art world.

Opposite Strong colours, simple elegant shapes and contrasting textures characterize the Prada brand's DNA.

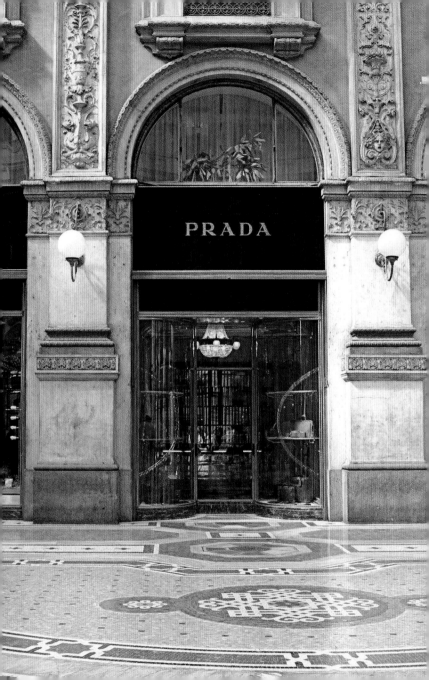

Heritage

Italy's fashion capital is home to one of the greatest success stories of the twentieth century. The address of this grand establishment is Via Bergamo 21, Milan – Prada's headquarters.

The Prada story began in 1913, when Mario Prada and his brother Martino opened a leather-goods shop in Milan's lavish Galleria Vittorio Emanuele ll. This landmark nineteenth-century shopping arcade, with its glass roofs and mosaics, linked Piazza del Duomo with Piazza della Scala. The shop, known as Fratelli Prada (Prada Brothers), specialized in high-quality leather products and luxury items, and from the start became known for its excellence. Today, Prada has evolved from its origins as an intimate family business to a global fashion brand, led by Mario's granddaughter Miuccia. Prada currently has a presence in over 70 countries, with more than 600 shops worldwide. Beyond fashion, but in keeping with its creative ethos, the label has expanded into new areas through ventures such as its non-profit making arts organization, the Fondazione Prada, and its America's Cup Challenge Luna Rossa sailing team.

Back in 1913, using only the finest craftsmanship and materials, Mario Prada's company delivered luxury, style and originality, attributes that would become synonymous with the family name. Fratelli Prada created the classic Prada walrus leather case and imported steamer trunks from England. Luggage, handbags, beauty cases and a range of exquisite accessories, including walking sticks and umbrellas, were sold. By 1919, after just a few years in business, Fratelli Prada was appointed official supplier to the Italian royal family. This entitled them to use the House of Savoy coat of arms and knotted-rope design in their logo, and this logo is still used by Prada today.

Opposite The first Prada store opened in 1913 in Milan's Galleria Vittorio Emanuele II. Mario and Martino Prada called it Fratelli Prada (Prada Brothers). From the start it reflected all the elegance, luxury and prestige that the brand is well known for today.

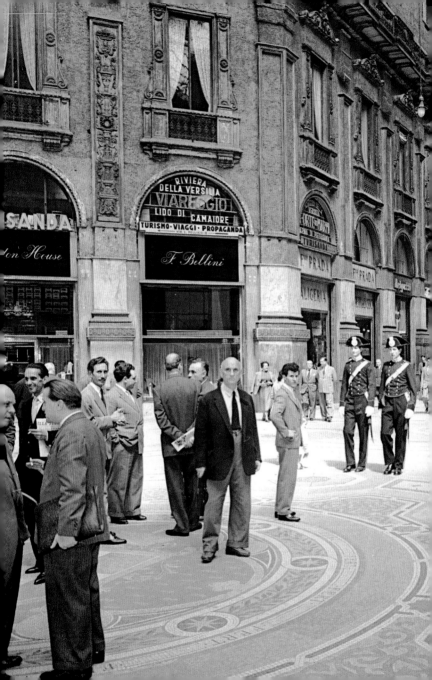

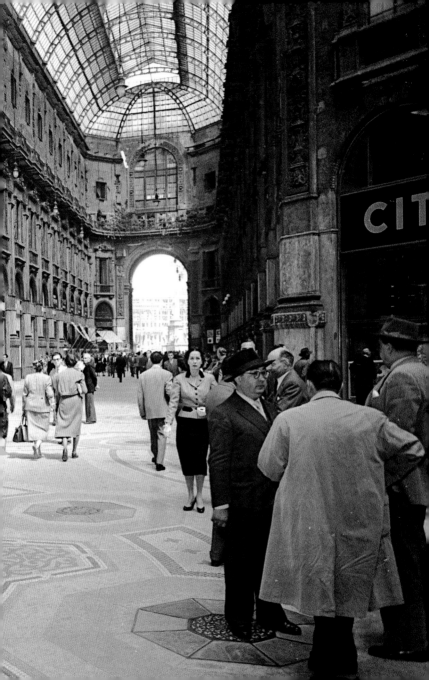

Miuccia Prada did not study design, pattern cutting or fashion, nor did she go to art school. Instead, after gaining a doctorate in political science from the University of Milan, she studied mime at the Piccolo Teatro di Milano in preparation for a career in acting, which she reluctantly had to leave to join the family business. Despite having what she describes as a dull childhood – she was made to wear plain

Previous page Milan's sumptuous Galleria Vittorio Emanuele II is home to Pradas's first store. The double arcade connects the Piazza del Duomo with the Piazza della Scala. It has an arching glass and cast iron roof – characteristic of nineteenth-century arcades – and spectacular marble and mosaic flooring. A majestic glass dome covers the central space.

Above Patrizio Bertelli had his own leather-goods business when he met Miuccia Prada in the late 1970s. The couple married in 1987, on Valentine's Day, and joined forces, transforming the family firm into a global brand.

Opposite A second Prada store opened in 1983 on Via della Spiga. It was just as luxurious as the first store, but with a more modern aesthetic.

striped dresses while dreaming of pink ones – she later took to wearing fabulous designer clothes, such as Yves Saint Laurent and Pierre Cardin, creating a very individual look. Her spirit and unmistakable sense of style have proved central to the reinvention of the Fratelli Prada business, taking it from a small family venture to one of the leading and most influential houses in the world of haute couture today.

Shortly after taking over the company, Miuccia met Patrizio Bertelli. Bertelli had his own leather goods firm and became her associate, focusing on the business side of things, as well as her husband. He has stood firmly by her side while she has devoted time to developing the brand's identity and direction. It was Bertelli who advised her to discontinue the English imports and to change their existing style of luggage – in 1979, the first line of nylon bags and backpacks was launched. Miuccia chose to use Pocone – a nylon fabric previously used by the company to line their trunks – because it fitted in with her love for everything industrial. This choice of fabric was technically challenging because nobody at the time was using it, and this made it more expensive to work with than leather. But Prada wanted to try

something new and exciting that was functional and beautiful in — the fact that these bags were almost impossible to make simply added to the challenge. Perseverance paid off, and although the Pocone bags were not an instant success, they eventually became the brand's first commercial triumph.

For the next few years Miuccia learned everything there was to know about the business and soon she and Bertelli began to expand. In 1983 they opened a second store in Milan, on Via della Spiga, that maintained the attention to detail that characterized the original store, while displaying a modern aesthetic.

In 1985 Miuccia created one of the most iconic fashion items to date: the nylon tote handbag. Still experimenting with Pocone instead of leather, the fabric gave the bag an edge and made the design so desirable that counterfeit copies were manufactured worldwide. This created an even greater buzz that strengthened the brand: Miuccia had elevated the status of this nylon fabric from industrial to luxurious. The black bag, with its high price tag and discreet, but unmistakable, triangular metal logo, became a must-have for fashion editors all over the world and put Prada firmly on the map.

A line of footwear was also introduced at this time, followed four years later by the launch of Miuccia's first ready-to-wear collections. Initially, her minimalist, clean lines received a mixed response because they contradicted the big shapes and power dressing ethos of 1980s fashion, but a shift in aesthetics was taking place and within just a few seasons her unique look had become synonymous with chic. Prada as we know it today had established itself.

Above Prada continued to expand
by adding a shoe line to its existing
accessories collection in 1979.
Prada's quality and craftsmanship
continued to be an integral part of
each and every one of its designs.

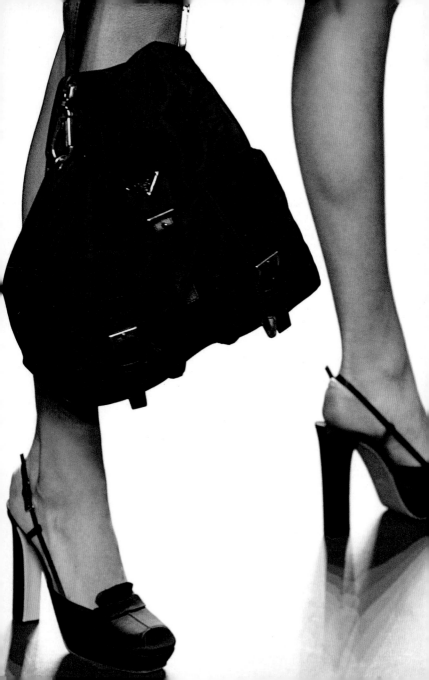

The Early Years

In the 1980s, a number of established, luxury, handcrafted travel goods companies – Hermès, Louis Vuitton, Gucci and Prada – began to diversify and break into new ground with a focus on accessories, which created a platform for later fashion collections. But Prada took the brave move to also transform its image, adding a unique utilitarian and urban dimension to the long-established brand. This not only revolutionized the concept of luggage itself, but more importantly it gave way to a new aesthetic of contrasting fabrics, textures and clean lines, which became very much part of the label's signature and design identity.

At this time consumers were beginning to use accessories as status symbols and handbags were particularly in demand. Prada's timing in launching the nylon tote was perfect and the innovative use of Pocone, a tough industrial fabric, in a luxurious context was an intelligent move. It influenced the luxury market, crowning Prada the must-have label of its time.

Until the late 1980s Miuccia's focus stayed on creating the select accessories for which her grandfather's company had always been known. Although a new identity had been born, the production process remained unchanged. Handbags, for example, were designed and sketched, then plotted to create a stencil that was laid onto the fabric or leather. These sections were then skillfully cut out and sewn together by highly experienced workers. Beautifully constructed, each bag bore the original Prada emblem that had adorned the luggage of past Italian aristocracy.

Opposite Prada's innovative Pocone nylon backpacks cleverly fused luxury and attention to detail with a fresh industrial approach to accessories. The discreet Prada logo was kept low-key, making a statement that reflected the overall aesthetic of the times.

Expansion into Accessories

At the same time, Prada was also stamping its mark on another new venture: footwear. Their manufacturing methods might have been traditional, but the shapes and materials they used were truly ground breaking, capturing the public's imagination with their ingenuity and inspirational approach. Moulded rubber soles were combined with leather and other fabrics that had previously been reserved for sports and performance-wear, and had never been seen before in the context of luxury. These included technical fabrics, such as mesh and perforated leathers that gave an almost Aertex or piqué-like texture.

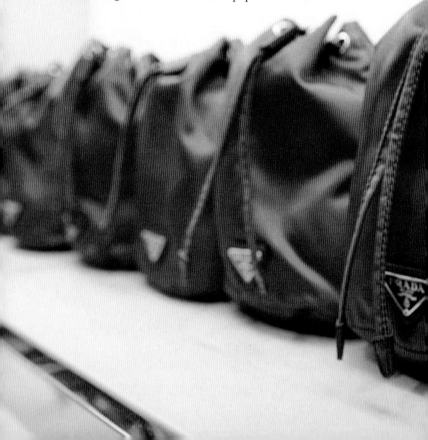

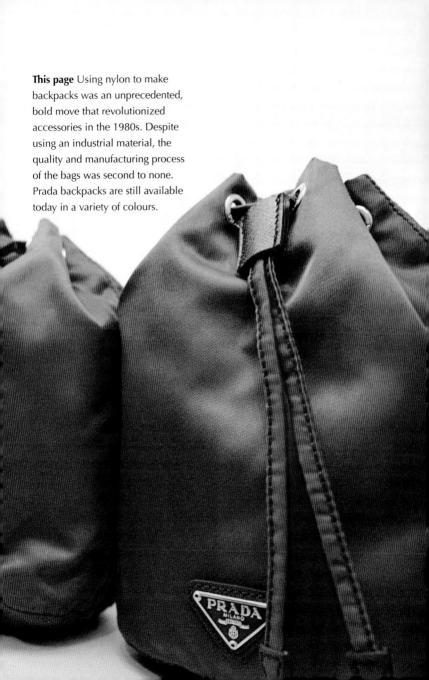

This page Using nylon to make backpacks was an unprecedented, bold move that revolutionized accessories in the 1980s. Despite using an industrial material, the quality and manufacturing process of the bags was second to none. Prada backpacks are still available today in a variety of colours.

PRADA
MILANO

This page and opposite The black Pocone nylon tote was launched in 1985, causing a stir in the fashion world and placing Prada firmly on the fashion map. Prada's handbags, in all their variations, have since become worldwide objects of desire owing to their quality and simple design.

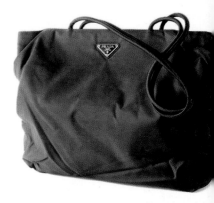

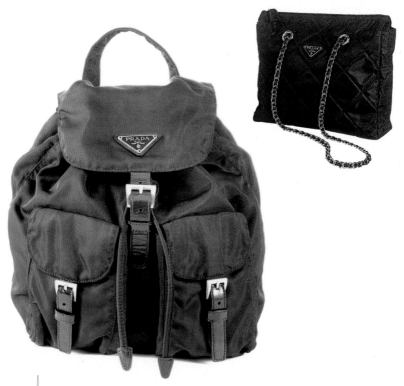

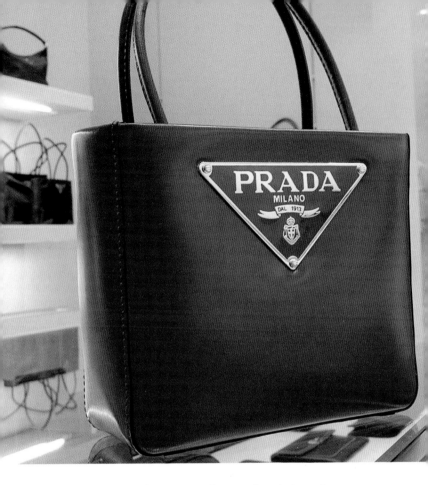

 This eccentricity and experimental approach to design, where modern and traditional techniques were fused together, resulted in a new perspective. Customers were now offered a delicate balance between classic and modern, which attracted creatives and fashionistas, as well as intellectuals.

 In 1993 Prada was awarded the prestigious Council of Fashion Designers of America award for accessories. In the same year Miuccia also established the Prada Foundation (Fondazione Prada), whose objective was to provide patronage and showcase the work of

contemporary artists. Prada's penchant for art would also influence the brand's fashion collections, which often featured illustrations, Pop and Op Art imagery. Now all eyes were on Prada, whose mainline fashion collections were strongly coming into their own. New lines followed: Miu Miu in 1993, ready-to-wear clothes, shoes and accessories for men (also in 1993), Prada Sport (with its legendary "red line") in 1997, and the Prada eyewear collection (in 2000).

Above A footwear line, launched in the 1980sreflected the ethos of Prada by adding a modern dimension to classic designs. Some of the materials used may have been modern, but the manufacturing process remained traditional.

Opposite Prada's eyewear collection was launched in 2000 and sunglasses have played an important role in accessorizing the collections ever since. These orange goggles, featured in the autumn/winter show 2011, complete the outfit by adding a futuristic après-ski feel to the look.

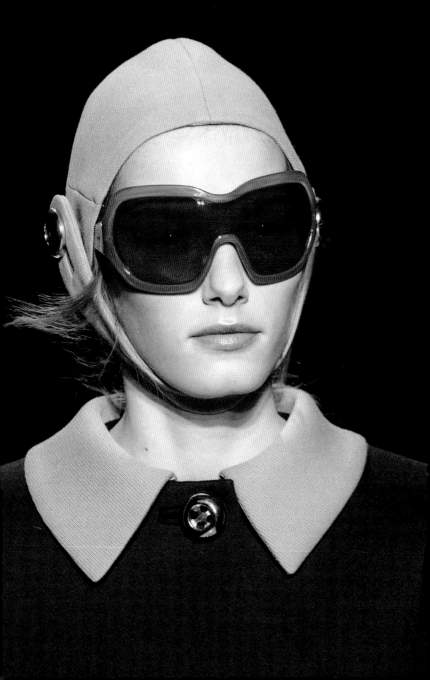

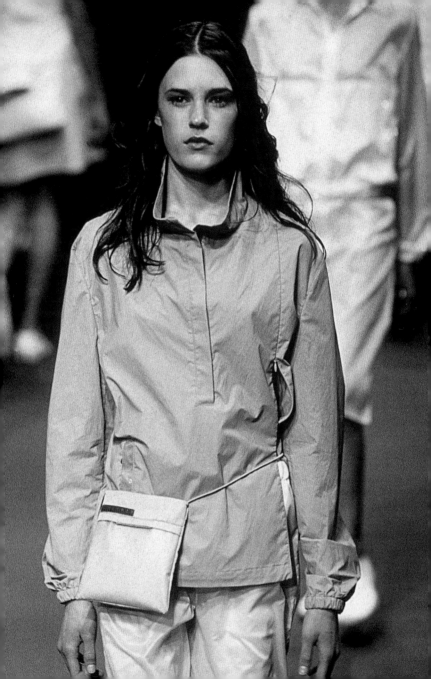

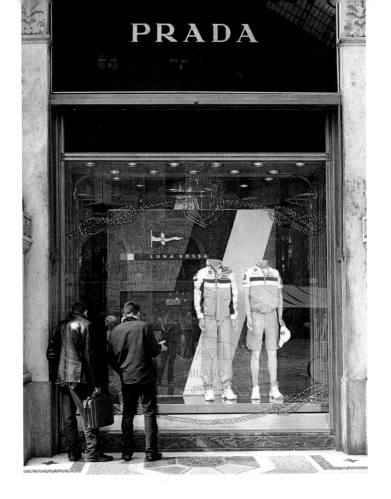

Opposite and above Prada Sport,
the range dedicated to leisure,
launched in 1997. Characterized
by its unmistakable red line label
and simple, clean shapes, it
elevated casual and sportswear
to the luxury arena, both in its
clothing and in its accessories.

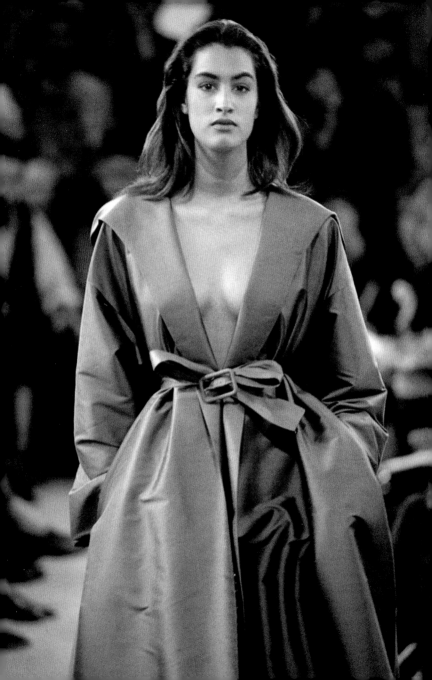

The Prada Aesthetic

When Prada was founded, the focus was on delivering tradition and luxury to Milanese high society in an opulent setting. By the late 1970s, when Miuccia took over as creative director and joined forces with her husband and business partner Patrizio Bertelli, change was inevitable if the brand was to survive. So they set their sights higher and raised the bar, creating a new Prada hallmark that has remained with the company through every stage of its development. The new ethos bound together an

"Always the problem with wanting to do structure is to do them in a way that still moves and is still comfortable, not really stiff."

Miuccia Prada

existing love of traditional values in an environment befitting the label's modern approach. Luxury and perfection coupled with a new avant-garde vision of the future found its expression in Prada's form of minimalism and was to become the brand's DNA.

This philosophy is reflected in all aspects of the business: from the way an item is designed, starting with a freehand sketch, to the company's deliberate decision to have employees of all ages working together. It is also present in the marrying of traditional techniques and craftsmanship, such as screen-printing and tie-dyeing with the latest cutting-edge technology. This can be so innovative at times that it is kept a company secret. By adopting this approach Prada has created a modern image of luxury that has pushed the boundaries and become unconventionally fashionable.

Opposite From the start, Prada's focus has been firmly on simplicity and clean lines to create beautiful yet wearable clothes. This voluminous, belted coat in nylon techno fabric, from autumn/winter 1990, was famously modelled by Helena Christensen in a dramatic black-and-white Prada advertisement.

The Minimalist Collections

One could argue that Prada's strength lies in its understated, quiet approach to fashion. The clothes are sexy and confident, but in a sophisticated and almost demure manner. Fashion reinvents itself constantly, just like art, reacting against previous trends and drawing on socioeconomic influences. It was not surprising then that after the 1980s, a decade of excess bursting with shoulder pads, neon colours, loud branding and logos, Miuccia's designs expressed a desire for simplicity, which was shared by designers such as Helmut Lang and Jil Sander. This new minimalism became Prada's trademark look and was welcomed with open arms.

To the untrained eye, the purist approach seemed almost too basic to work, but on closer inspection there was always a subtle, experimental twist. This may have escaped a large number of onlookers, but for those

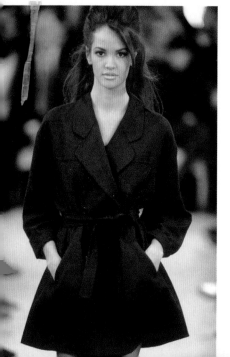

Left The volume in this jacket from spring/summer 1992 is cinched with a narrow belt. The short, swinging length helps to create a defined, structured shape, as an alternative to the fluid hourglass.

Opposite A military influence is apparent in this high-neck, streamlined black ensemble for autumn/winter 1993, decorated only with highly-polished buttons and belt buckle. With a restricted colour palette and an emphasis on fabric rather than pattern or embellishment, Prada spearheaded the minimalist movement. Prada also launched the Miu Miu line in 1993, as the visionary sister label to the main fashion powerhouse.

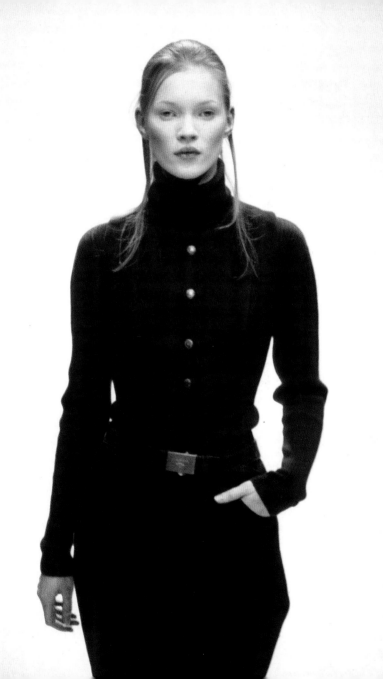

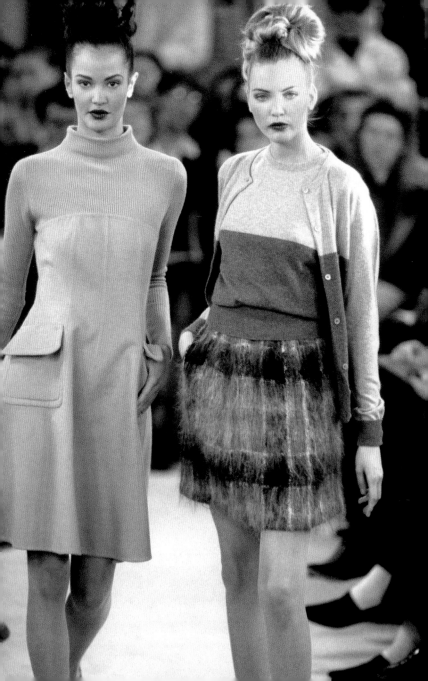

in the know who appreciated and understood such subtleties, it added strength and value to the brand.

Prada's fluid lines and contemporary shapes provided a template that allowed Miuccia to work conceptually, giving her room to experiment with textures, fabrics, prints and colours. Her approach to design is a process whereby she surrounds herself with experts who can interpret her visionary ideas and bring them to life.

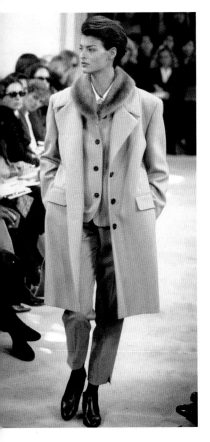

Opposite The spring/summer 1997 collection was feminine with 1950s influences. The cardigan, seen here in two shades of blue and worn as part of a twinset, would become a staple Prada piece that is both practical and elegant. The camel dress is simple in its shape, with a full skirt that adds fluidity to the garment as it moves.

Left Layering classic garments with accents of texture creates a modern, timeless and elegant look. In a subdued colour range of grey, black and white, this collection captures the mood of the early 1990s with its relaxed, simple and effortless beauty.

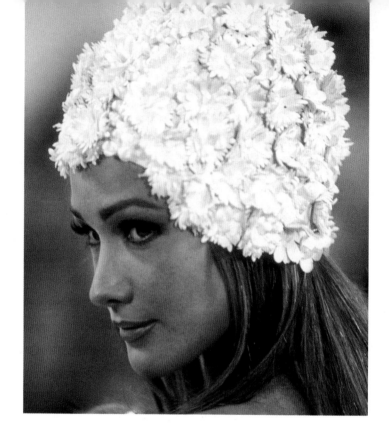

Above This white, summery hat looks like an ornate early 1960s swimming cap. Decorated with flowers, it is the perfect accessory for the spring/summer 1992 show, adding glamour, fun and a touch of irony in one simple accessory.

Opposite Strong patterns and clean lines are characteristic of Prada's designs. This dress, from 1992, has a provocative slit at the front that reveals matching shorts. The summery red-and-white stripes elongate and give structure to the outfit.

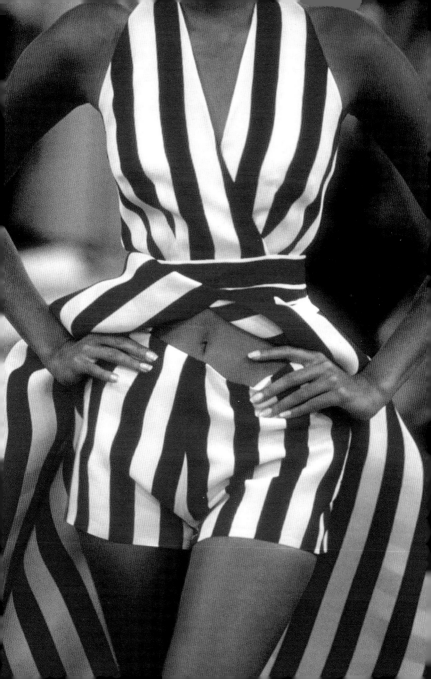

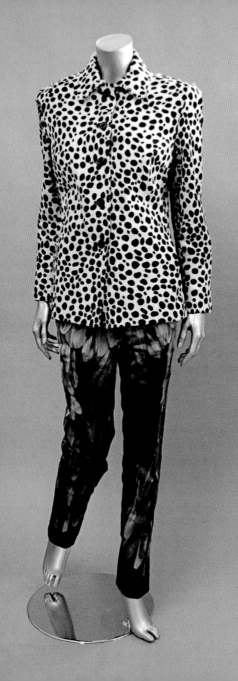

Opposite and above This outfit
combines a piebald ponyhide jacket
with a pair of blue silk, wing-print
trousers. Contrasting patterns and
original colour combinations are
part of Prada's signature, creating
garments that are innovative and
exquisite. Prada's use of colour is
often unorthodox and unusual in its
combinations, but the results, such as
the ochre, pale blue and brown used
in the print for the trousers, are superb.

Colours, Prints and Textures

The label's quirky use of prints has been ongoing since Miuccia launched her first ready-to-wear collections. From the onset, the colour combinations were often unusual (for example, chocolate brown, lime green and white checks from spring/summer 1996), and the choice of prints were closely linked to the narrative running through each collection. In spring/summer 2000 the iconic print of lips and lipsticks added a hint of Pop art to an otherwise classic look.

Right Prada's design simplicity allows for interesting textures and colour combinations. Mustard yellow, olive green and powder blue were central to the spring/summer 1996 retro colour palette, which became known as the "Formica print" collection due to its references to 1960s kitchen vinyl patterns.

Opposite Miuccia Prada often revisits previous eras as influences for her collections. The pattern used here combines lime green, chocolate brown and white in a check design that harks back to the 1970s. The shape of the double-breasted coat and its short length is reminiscent of a 1960s miniskirt trend.

Overleaf Unusual textures, such as the peacock feathers on this skirt, shone in the spring/summer 2005 collection.

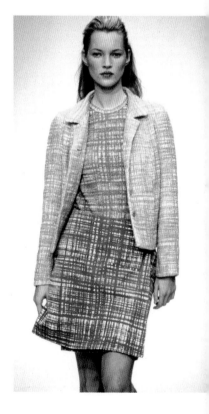

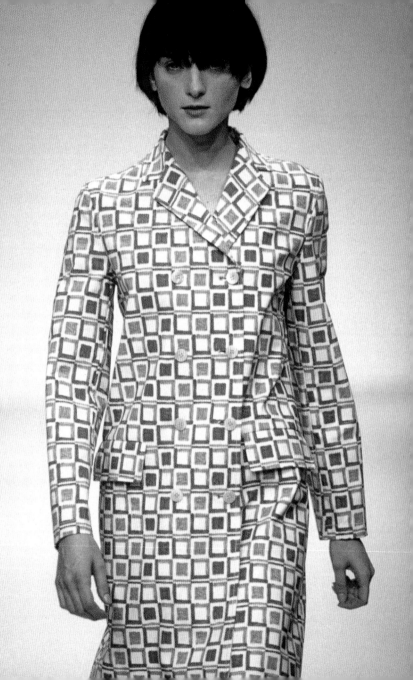

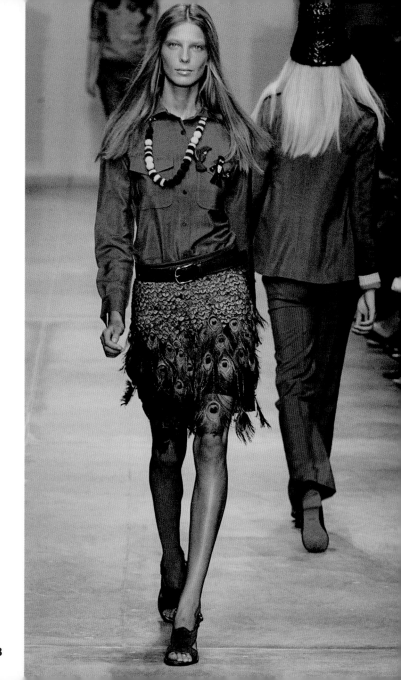

Autumn/winter 2003 saw the inclusion of striking William Morris prints in a winter-warming collection of tweeds, while in spring/summer 2008 illustrator James Jean was commissioned to create a fantasy fairy print, adding a further dimension to an unexpectedly soft and flowing show (see also pages 108–113).

Miuccia also uses texture as a form of expression, sometimes in a provocative way, challenging preconceptions and taking elements out of context. Examples of this include a dress made entirely of fringing in spring/summer 1993, the oversize mirror detailing featured in spring/summer 1999 (more traditionally found in Indian saris and sewn into the fabric like large sequins), and a skirt made out of peacock feathers for spring/summer 2005.

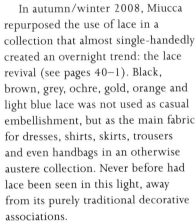

In autumn/winter 2008, Miucca repurposed the use of lace in a collection that almost single-handedly created an overnight trend: the lace revival (see pages 40–1). Black, brown, grey, ochre, gold, orange and light blue lace was not used as casual embellishment, but as the main fabric for dresses, shirts, skirts, trousers and even handbags in an otherwise austere collection. Never before had lace been seen in this light, away from its purely traditional decorative associations.

Left The spring/summer collection of 1999 showed some interesting oversized mirror detailing, sewn onto delicate garments, echoing the sequins found on traditional Indian saris and adding texture to an otherwise minimal look.

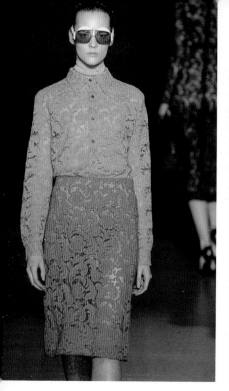
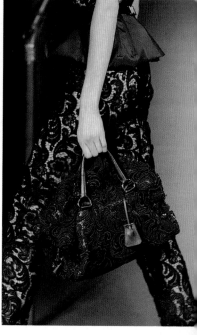

Above and opposite Defying tradition, lace was used in the autumn/winter 1998 to create complete garments and accessories rather than to embelish. The colours used were unusual for this type of fabric, and included black, brown, grey, ochre, gold, light blue and orange. The bright orange lace pencil skirt (above left), teamed with a camel lace shirt and orange sunglasses, is a great example of this unusual use of colour. Prada also used lace in this collection to make accessories. A black lace bag, with leather handles, matches black lace trousers (above right).

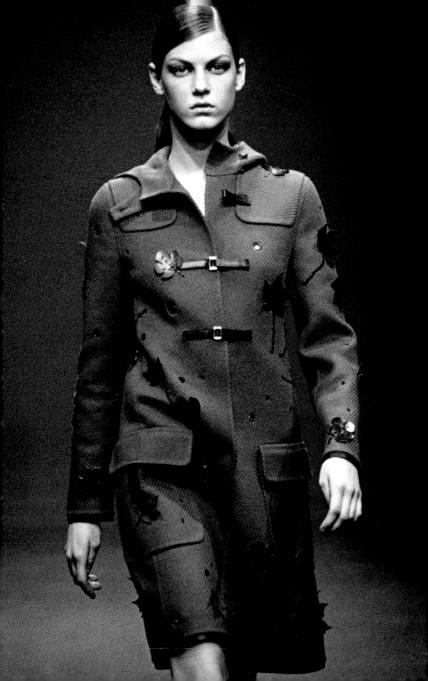

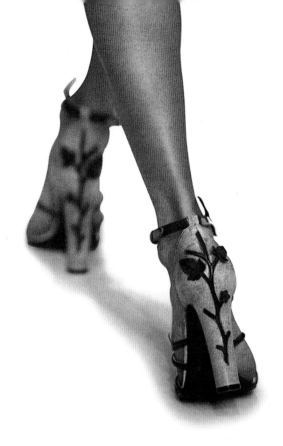

Opposite A military trend is present in many of Prada's collections. This brown coat from autumn/winter 1999 has two leather straps to fasten it at the front and leaves sewn all over it, adding texture and originality to an otherwise classic, no-fuss and utilitarian garment.

Above The shoes from the autumn/winter 1999 show were also decorated with foliage in leather appliqué, adding texture to a classic shape.

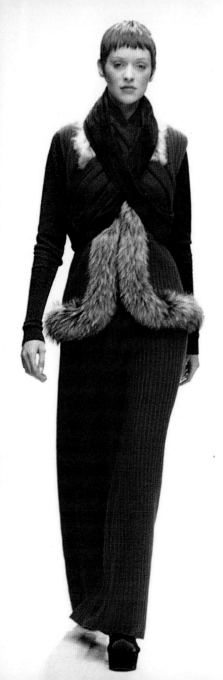

Left This full-length, fitted, textured dress in a stunning burnt orange hue, with fur trim over a chocolate brown top, played with texture and colour in autumn/winter 1993. Layering a rusty brown neckpiece adds to the overall look.

Opposite This dress, in an opulent golden shade of ochre, is from autumn/winter 1993. It is worn with an unbuttoned, chocolate-brown coat with structured, trimmed lapels. A purple hat and lace-up boots complement the outfit in an original colour combination.

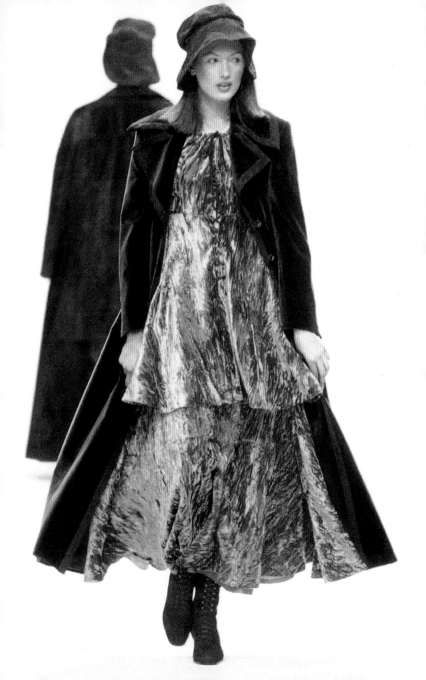

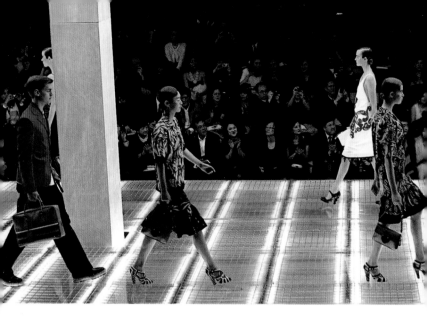

Selling the Prada Look

Prada's past-meets-future ethos is also evident in its advertising campaigns, which have a strong and novel editorial narrative. Every campaign tells a carefully recounted tale in which the mood created and the model's expression become key. The clothes, which ironically become almost incidental, are part of a fantasy designed to appeal to consumers worldwide. The campaigns bring together the best production teams – headed by leading photographers such as Steven Meisel, who has shot the campaigns since 2004 – who interpret and convey Prada's modern vision.

Presenting a collection to the public creates yet another opportunity to showcase the essence of the brand. Prada's approach, no doubt influenced by Miuccia's time at the Teatro Piccolo, can at times be as theatrical as any major theatrical production. Since 2000 Prada has used a converted factory in Milan on Via Fogazzaro to host its shows. Time after time, the space is transformed through installations, screens and décor to fit with each collection's concept and deliver its specific

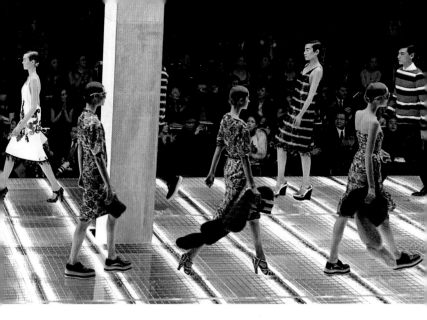

message. No detail is left to chance, from the design of the invitation and even the thickness of the envelope to when a choice of canapés is offered to the arriving guests. Everyone is left guessing and trying to join the dots, because although the Prada handwriting is unmistakable, it is also unpredictable. The lighting, music and seating plan are all part of a phenomenal production that transports the audience of fashion editors and buyers into a new world, daring them to suspend their disbelief and expect the unexpected.

Old and new, traditional and innovative... everything in Prada's world is touched by compelling and thought-provoking energy.

Above Prada uses every fashion show to convey the unique Prada experience to a select and influential audience. Spring/ summer 2011 combined colour, stripes and remarkable accessories – including striped fur stoles and shoes with three soles fused together as one – to produce a vibrant and summery show bursting with energy. The models' make-up harked back to the 1940s, with gelled, waved hair and silver eyeshadow.

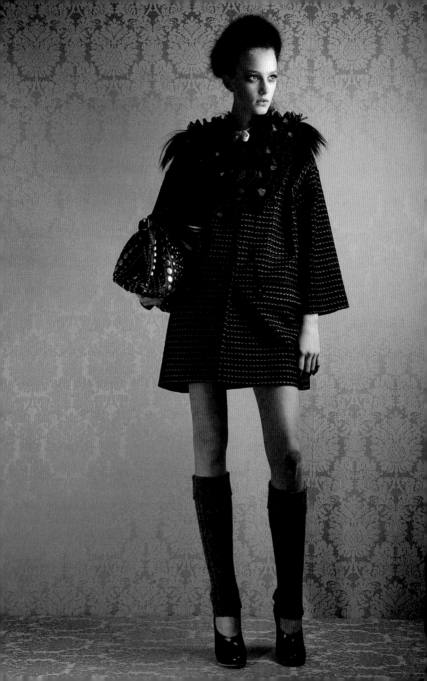

Miu Miu:
Prada's Little Sister

In 1993 Prada launched a second label, which was named Miu Miu – Miuccia's nickname since childhood. This diffusion line was more affordable and directed to a younger customer, casting the Prada net still wider. Overall, Miu Miu has a very different energy to the mainline Prada collections: more youthful, vibrant, colourful, and at times sexy, eccentric and bohemian. It also places less emphasis on luxury and projects a greater sense of adventure. Although the two collections are clearly separate, there is a family resemblance and Miu Miu is often referred to as "Prada's little sister".

Miu Miu's triumph lies in its ability to encapsulate the effortless sense of cool that certain individuals seem to posess, throwing "any old thing" together and always looking fantastic. Often the styles – a skirt, a dress, a pair of trousers – appear simple at first sight, but their cachet is clinched by the original use of fabrics or prints.

From inception, Miu Miu captured the mood of the moment and created looks that were extremely wearable and accessible to fashion lovers. The label's identity – younger and less sophisticated than Prada – was reinforced by the eclectic advertising campaigns it ran. These sometimes used celebrities, such as Drew Barrymore, Chloë Sevigny, Katie Holmes and Vanessa Paradis, and in-vogue editorial photographers, including Terry Richardson, Juergen Teller, Mario Testino and the late Corinne Day.

The many faces of the Miu Miu girl contain infinite influences, making the brand impossible to pigeonhole. There are, however, some recurring themes that shape and define the label's personality.

"It's about the bad girls I knew at school, the ones I envied."

Miuccia Prada

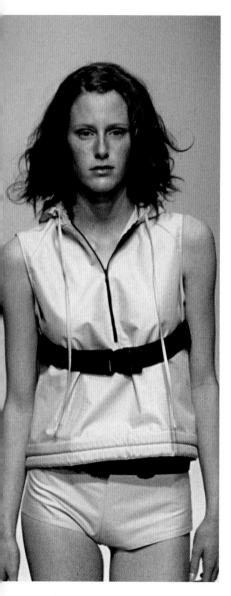

Previous page For pre-autumn 2009, Miu Miu displayed playful elegance. This model is wearing a 1960s-inspired, embellished swing coat with wide arms and leggings with high heels.

Left The spring/summer 1999 collection was heavy on sports and leisure influences. This sleeveless, hooded top with a black zip is matched with very short shorts that add a quirky twist to an otherwise standard ensemble.

Opposite Military green is used here to create a dress with unexpected feminine detailing on the pockets and sleeves. In contrast, an orange belt bag creates definition and adds shape to the overall silhouette.

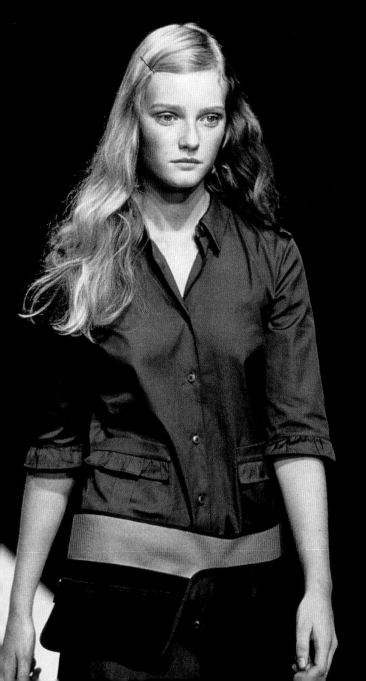

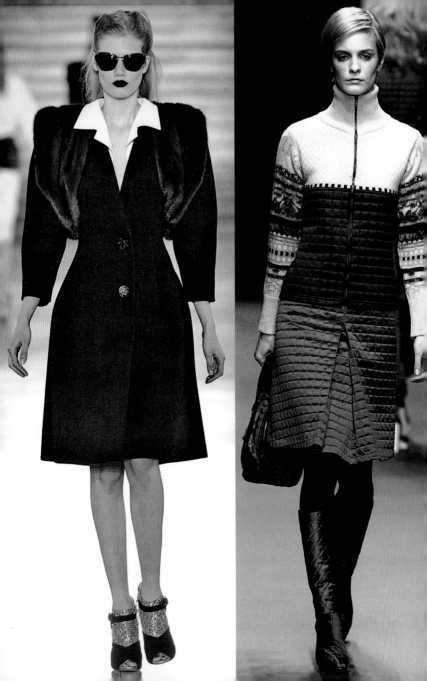

Plundering the Past

Revisiting past eras is something Miuccia Prada admits to having done since the very beginning of her fashion career – and it is also something for which she has become well known. Like a magpie, she has a way of collecting and bringing together retro highlights in a feminine and particularly girlie style. In "Portrait of Hailee" – the 2011 campaign shot by Bruce Weber – the collection is shot in *film noir* style, with a dramatic classical music soundtrack reminiscent of a silent movie. It features actress Hailee Steinfeld simply being herself – lying on the grass, sitting on a train track, daydreaming, laughing and eating pizza slices with her hands – and combines elements of vintage, such as beaded embellishments and calf-length dresses with modern touches, including coloured glitter shoes, to give an aura of upbeat nostalgia. This sentiment is also expressed through the elegance and sharp-suiting shapes of the 1940s, which are sometimes portrayed in an informal way (autumn/winter 2002 was a casual collection, which was feminine, pretty and playful with its use of delicate pale pink chiffon, striped T-shirts and wool skirts) and other times in a more mature, demure light (autumn/winter 2003 showed ankle-length classic dresses, skirts and smart hipster trousers worn with finishing touches of fur).

Opposite left The sharp, suited shapes of the 1940s were present in the autumn/winter 2011 collection. Sunglasses and fur tippets referenced Hollywood's glamorous Golden Age, reinforced by classic red lipstick.

Opposite right A further reference to the 1940s is seen in this elegant silhouette from 2002. Texture, in the form of quilting on the outfit, bag and boots, and colour add a modern dimension.

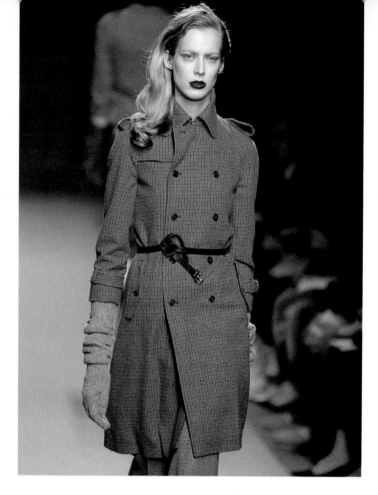

Above This double-breasted, military green coat, from autumn/winter 2002, is tied (not fastened) at the waist with a thin belt, softening an otherwise unisex garment. The models, with their side-parted hair and red lipstick, echo an austere wartime aesthetic.

Opposite Flashes of pink, yellow and green in a retro pattern on the model's top, lift what could otherwise be a fairly sombre outfit. The fur scarf and mohair sleeves create textures and layering, and the knotted belt and handbag complete the feminine look.

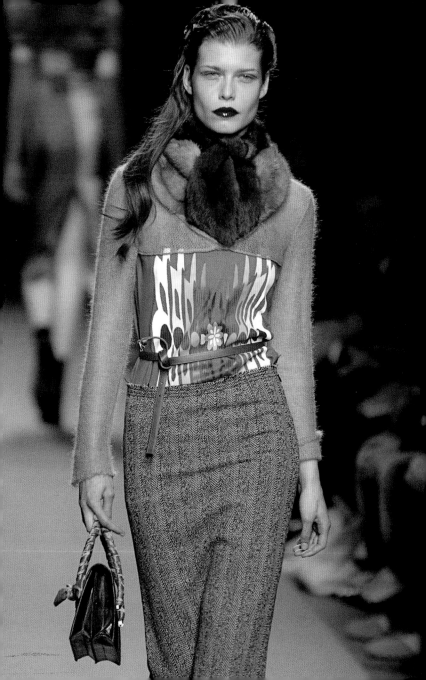

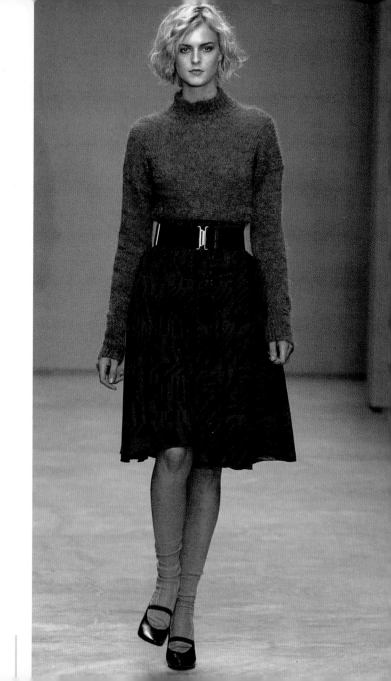

Preppy Chic

The simplicity of Miu Miu lends itself perfectly to the preppy look: neat, understated and with a focus on quality and classic shapes. When interpreted by Miu Miu, it has an almost-grown-up air, perfectly captured in the spring/summer 2000 show, "Almost a Lady", characterized by pleated skirts and baseball jackets. Spring/summer 2001 saw Prada take a modern twist to preppy, merging a 1950s shape with 1980s references such as drop-shoulder jackets to give an overall urban flavour. Big elasticated belts and full skirts were key, while the use of long socks with stilettos added a schoolgirl reference.

Another key feature of the preppy ensemble is the cardigan, which is present throughout the collections. Sometimes worn on its own, and often belted to accentuate the female form, it has become a staple Miu Miu garment, integral to the brand's aesthetic. Accessories such as hoop earrings, chain necklaces and wide, coloured Alice bands consolidate this look, reinforcing the air of innocence that Miu Miu so reassuringly delivers again and again.

Opposite Model Jacquetta Wheeler wearing a full red and black skirt, with a wide black belt that fastens at the front with a gold buckle. A simple grey knitted sweater with a high neck and grey socks paired with pointed heels add to the overall girlie look, so typical of Miu Miu.

Right Socks worn with high-heeled shoes add playfulness to the collection, and emphasize the youthful spirit of the brand. Here, colourful, geometric-patterned shoes stand out against a pair of plain, ribbed grey socks.

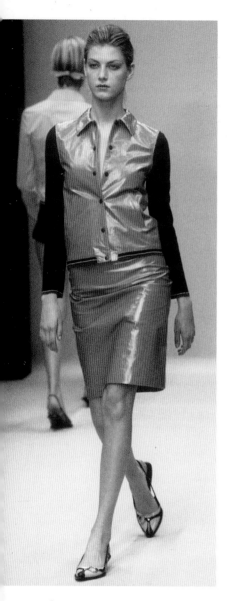

Left Bubblegum pink and black
are the perfect combination for
this preppy ensemble from spring/
summer 2000. The two-tone jacket,
reminiscent of a 1950s bomber
jacket, matches the pencil skirt and
ladylike pink and black shoes.

Opposite Camel and light brown
combine effortlessly here in a belted
look that incorporates many of the
key Miu Miu elements, including
preppy styling, for 2002.

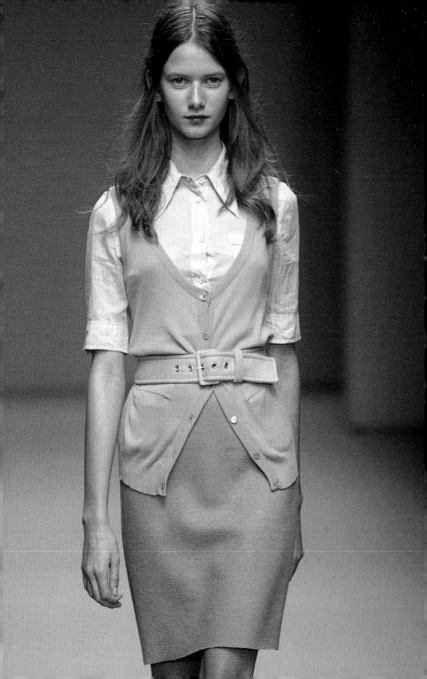

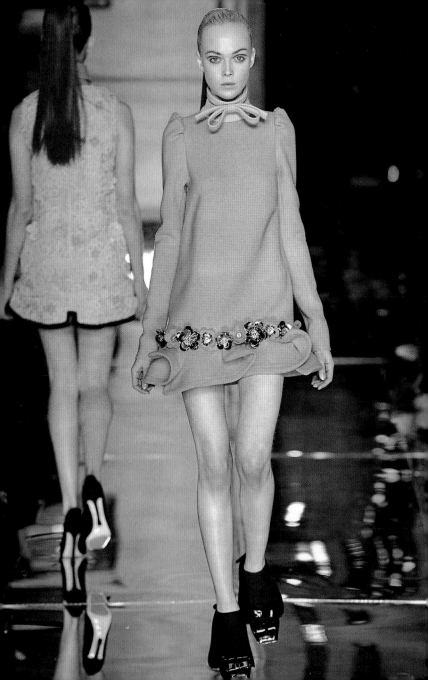

Sixties Scene

A-line dresses, Mary Quant flower references and platform shoes are all intermittently present in the Miu Miu universe, often in a way that incorporates the fitting, vibrant and lighthearted energy of 1960s fashion. With its narrow lines, neat minidresses and pretty skirts structured to create volume, the autumn/winter 2010 show was unusually sophisticated. Flower detailing embellished the fabric and high necklines with thin pussycat bows gave the look a sweet and up-to-date twist.

This trend, above any other, seemed to have captured the hearts of fashion editors: in August 2010 a very modern-looking 1960s-style dress from the Miu Miu collection featured simultaneously on the cover of *British Vogue*, *British Elle* and the US magazine *W*. Never before had this occurred – a feat that was evidence of the brand's popularity and its ability to connect globally, which no doubt put a smile on Miuccia's face.

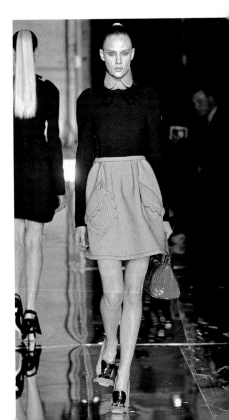

Opposite The autumn/winter 2011 collection was inspired by the 1960s. This orange A-line minidress, with silver flowers attached to the base, is accessorized with a pussycat bow and black shoes.

Right This lilac skirt, worn with a fitted black top with bow and a striking orange collar, is accessorized with a structured handbag, also in orange, and elegant high heels. The model's pulled-back hair adds to the severe composition of the look, which is softened by the feminine pocket detailing on the skirt.

Stars and Stripes

Often dresses on the Miu Miu catwalk are simple in their design. However, as with the mainline Prada range it is precisely this bareness that allows for prints to take centre stage. In a sense, the prints make the clothes special, something we see time and again in the work of Miuccia Prada. The 2008 autumn/winter print campaign, featuring Vanessa Paradis, is a perfect example. One of the shots is a close-up of the actress looking up, her head back and her eyes closed; you can only see the top of a dress, which has a strong pattern of orange, black, cream, chocolate brown and red. It's all about the girl and the print, a powerful image that exudes cool.

Overleaf right Autumn/winter 2008 was a collection inspired by jockey uniforms. The models wore "horse hoods" with their ponytails sticking out of the back, and had personalized leather initials sewn onto their clothes.

Overleaf left Nobody clashes prints better than Miuccia Prada. The spring/summer 1995 collection combined 1970s patterns in a variety of colours and styles. This retro shirt in lilac and browns blends effortlessly into a red, blue, brown and white skirt. The blue Alice band and fresh-faced make-up add a cool edge to the look.

Opposite Accessories are as much a part of the narrative of a Prada show as the garments themselves. This bag, with tan leather detailing, complements the retro-style dress by using a similar pattern in a slightly different colourway. By purposefully mismatching the patterns it creates a sense of contrast.

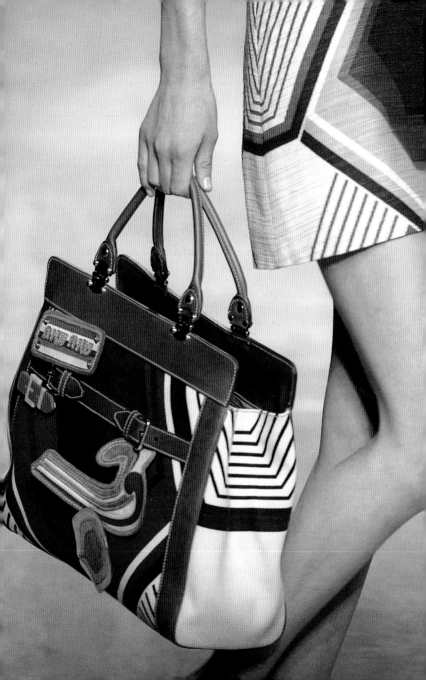

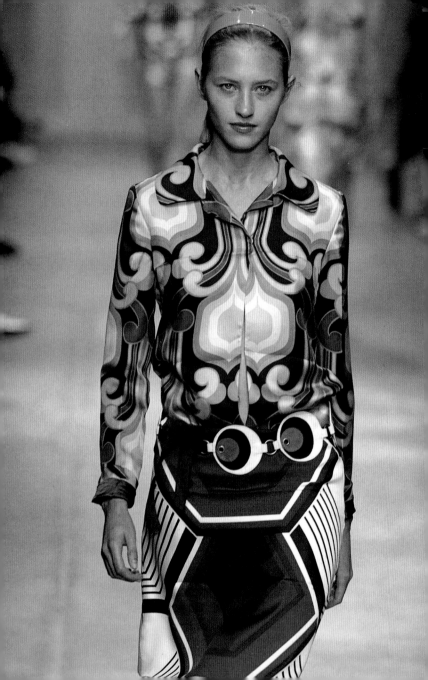

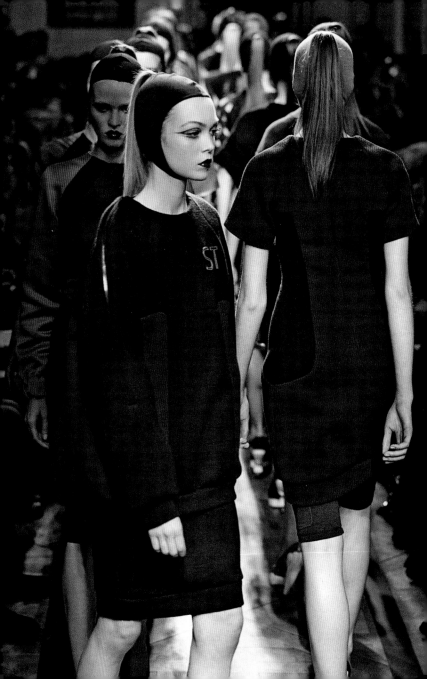

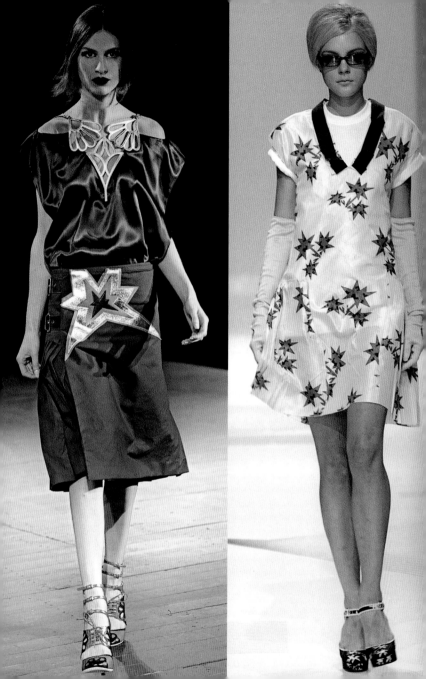

Retro prints resembling furnishing fabrics from the 1970s were seen in the 2005 spring/summer collection, a show that was all about simple shapes with bold and confident patterns in combinations of browns, ochres, greens and blues. Softer, prettier and more girly feminine prints are also prominent in Miu Miu: dresses with star prints in lemon and rose for 2006 and prints of animals for 2010. In 2011, stars, animals and lotus-flower prints were present in a glam-rock collection inspired by the current obsession with fame. Clashing of prints is another interesting format achieved either by combining two different prints or mismatching within a design. In spring/summer 2012 prints and patchwork appeared on boots, bags, dresses and a selection of gorgeous capes tied at the front or on the side with a thick, black ribbon. Worn with high-heel clogs and Western-style boots that added a folkie flavour to an otherwise Gothic collection, they stole the show.

Opposite left The spring/summer 2011 show was an exploration of fame, with glamorous and striking outfits. This silk satin shirt with silver latticework on the front is worn with a skirt featuring a star motif on the front. Fuchsia-coloured strappy heels add to the "rock chick" look.

Opposite right Miu Miu often uses pretty prints, such as this dark star design on a pale yellow background. The dress, worn here over a white T-shirt, is accessorized with sunglasses, long gloves and high heels, which add to the confident style that themed the spring/summer 2006 show.

Right The prints used in the spring/
summer 2010 collection were thought-
provoking and delicate in equal
measures. This outfit combines images
of white dogs on the black mini skirt,
with nude female figures on the soft
brown blouse and red collar.

Opposite A lotus flower print on
silk gave an oriental flavour to the
glamorous spring/summer 2011
show. A thin blue belt cinches the
dress to create a ladylike shape.

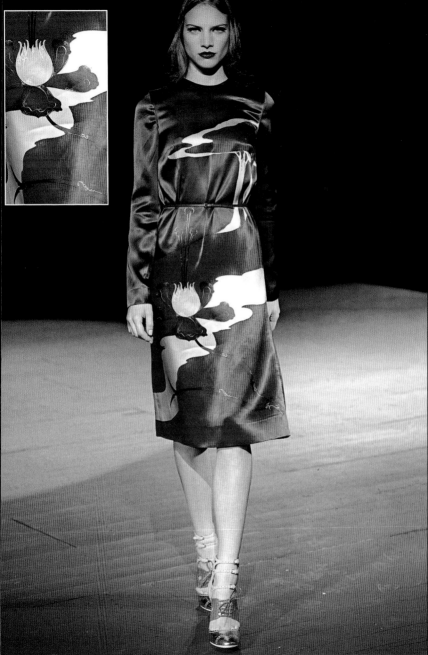

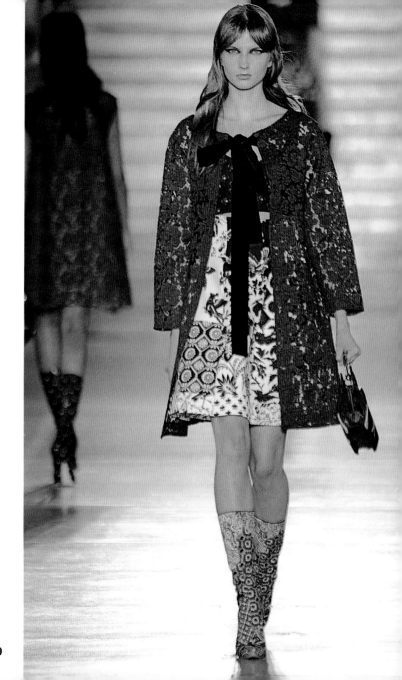

Sexy Sirens

Miu Miu's approach to sensuous dressing takes many different guises
and, as the brand evolves, it becomes ever present in collections through
the styling and general attitude of the shows. In autumn/winter 2002,
for example, high boots were worn with hotpants and overcoats, while
in Spring 2008 extremely short dresses, evocative of French maids,
Alice in Wonderland and *Playboy* bunnies, added a theatrical glow. The
alluring and sexy advertising print campaign that accompanied the
season, starred actress Kirsten Dunst and was shot by partners Mert Alas
and Marcus Piggott, and featured a provocative 1950s-inspired pin-up
look.

Opposite This outfit, from spring/
summer 2012, shows an interesting
combination of patterns in the
patchwork-style dress and boots. The
bag has a geometric pattern in pink,
black and red, with a gold handle.

Right Two models backstage at the
spring/summer 2008 show. The
model in the foreground is wearing
red lipstick to match her high-heeled
shoes, a black and white puffball
dress with white bloomer shorts,
white cuffs and a black choker
reminiscent of a *Playboy* bunny.

Overleaf left and right A multi-
coloured, puffball minidress is
beautifully accessorized with orange
sunglasses while a delicate dress
with a puffball skirt adds drama
to a simple shape, both 2008.

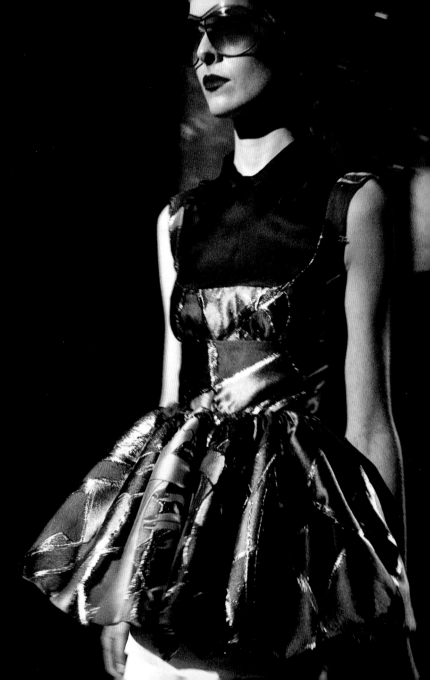

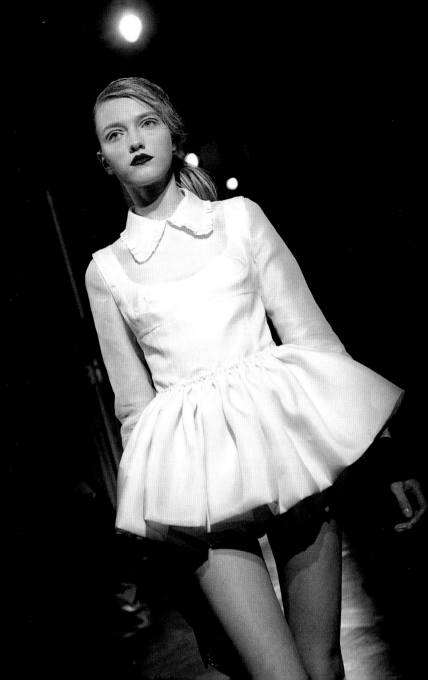

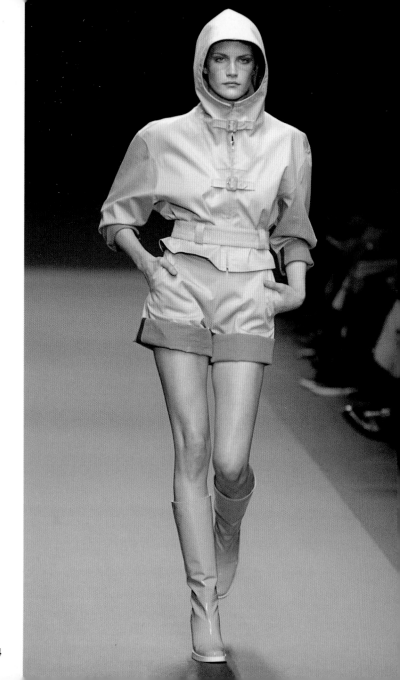

After showing in Paris for the first time in autumn/winter 2006, a new chapter began for Miu Miu. As Miuccia herself commented, this was a way to make the diffusion line more special and important. Indeed, there is a palpable sense that this was the turning point for the brand, as if a newfound confidence had transformed the girls into young women. The venue chosen for the occasion was the famous eighteenth-century Lapérouse restaurant on Paris's Left Bank. Unprecedented touches of luxury accompanied this collection and its grown-up look was more sophisticated than anything previously shown. With red lips, short dresses and skirts, the models had a provocative air about them. Printed silks, long gloves and platform shoes with carved-out detailing on the heel proved to be complete showstoppers and the icing on the cake.

Opposite Shorts and high boots give a sensuous, but space-age, look to a 2002 utilitarian outfit of camel hooded jacket and shorts.

Right Autumn/winter 2006 was Miu Miu's first show in Paris, reinforcing the brand's stand-alone identity away from the mainline Prada collection. The models, who all wore matt red lipstick, looked confident and mature in the less girlie and more luxurious collection that included this silk dress with a still-life design photo-print.

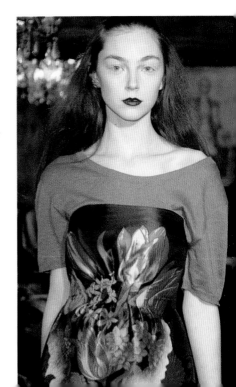

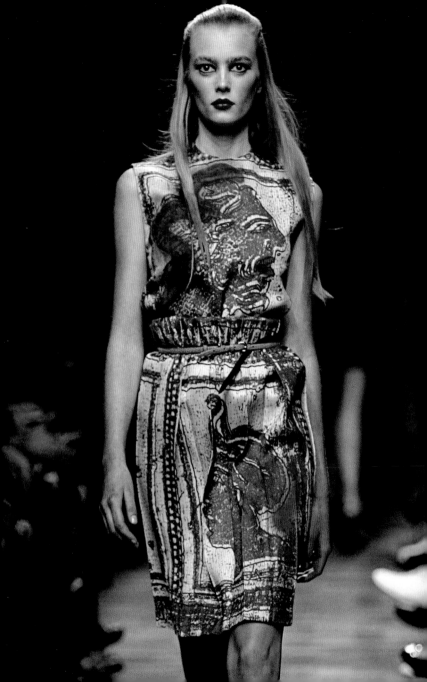

Opposite Miucca's investigations into European history is reflected in the printed fabric of this simple dress from spring/summer 2009. Inspired by ancient Roman tiles or coins, a graffiti spray effect adds a modern touch.

Right and below The same bright pattern is used on the sleeveless dress and the sideways apron, which deconstructs the silhouette and adds structure to the dress.

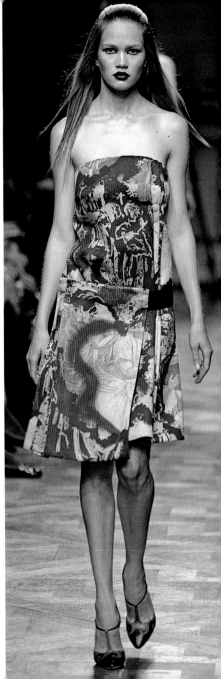

Menswear

In 1993, Miuccia Prada launched her first full menswear collection, which included footwear and accessories. Not only did the designs capture her mood, but season after season the collections kept Prada's brand identity running through consistently. A meticulously thought-out process is reflected in each garment, ensuring that beyond the shapes and silhouettes, elements of functionality such as pockets or the use of resilient fabrics play a vital role in the aesthetics of the line.

The mastery of contrasting and opposing elements is one of the strengths and signatures of the menswear range, something that is achieved in a number of ways. Prints range from 1970s-type patterns (autumn/winter 2003) to more abstract designs (spring/summer 2005) and candy-coloured florals (spring/summer 2012) and are all effortlessly combined with formal suiting to bring together both ends of the style spectrum. Unsurprisingly, texture is also used in an exploratory way and as a means of expression. High-twist nylon yarns normally employed in woven technical garments, for example, are utilized to create knitwear, while mohair knits – usually associated with womenswear – create interesting combinations, both visually and to the touch, with matt worked against high gloss or smooth against rugged, fur-like finishes. And in autumn/winter 2007 a series of garments (vests, tops and coats) in coarse, long-hair fabrics were shown alongside head-to-toe angora (hats, sweaters and leggings).

Unisex aesthetics and a look at duality were showcased in autumn/winter 2008, in a collection with a more conceptual approach. The runway presentation included garments such as bib-like tops, suggestions of jockstraps or skirt-like panels over trousers – Miuccia Prada at her most inventive and controversial.

Opposite Prada Men was launched in 1993, and included footwear and accessories. Over time, the collections have acquired a reputation for being meticulous in their execution and performance.

Overall tonal dressing reminiscent of the early minimalist ethos is something Prada has completely mastered over time in a way nobody else has done. In fact, it has become part of Prada Men's inherent individuality. Varying shades of navy, camel or grey may be worn with ease from head to toe, reflecting a lifestyle so understated it can be adapted to become one's own. And although fashion keeps reinventing itself, there are many classic, ageless shapes that can be loved and worn over and over, standing the test of time. Prada has established itself as a brand where a must-have item becomes a wardrobe investment, in particular the tailoring and outerwear garments that underpin the menswear range. Still today, it remains a highly aspirational brand and one that constantly challenges our idea of luxury.

Left Monotonal dressing is one of many distinctive trends favoured in the menswear line. Here, in the spring/summer 2006 collection, the model wears browns and greys in a classic suit, dressed down with silver trainers (sneakers).

Opposite A striking green V-neck jumper, worn over a shirt and tie, echoes a casual preppy look.

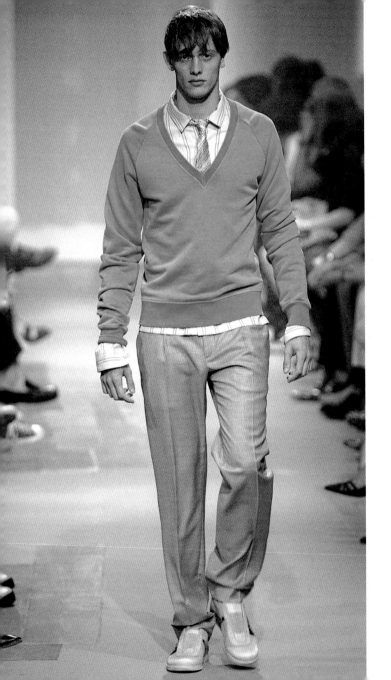

81

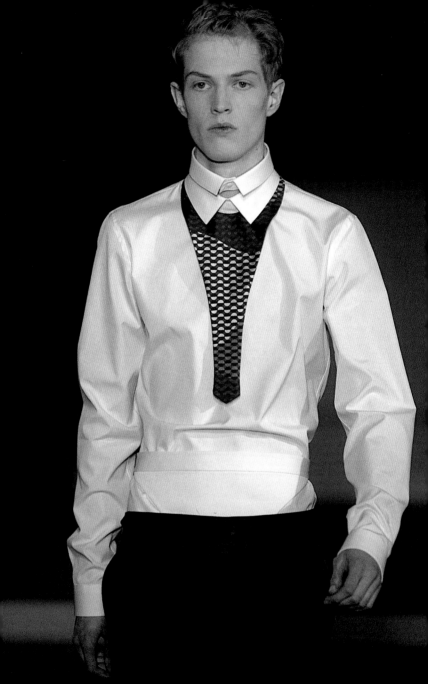

Opposite A particularly conceptual collection in autumn/winter 2008 looked at duality, and included double shirt collars, bib-like tops and hinted at jockstraps over the lower part of the shirts.

Right A striking coat with black and gold squares adds flair to a classic outfit of black trousers and tie worn with a white shirt.

Overleaf left The autumn/winter 2003 show prominently featured 1970s-style patterns. Here, a yellow, black and white tie clashes with a geometric-patterned shirt in white, blue and brown.

Overleaf right Prada expresses attention to detail through accessories. Here, a suit is worn with a multicoloured check trilby hat and a clashing tie.

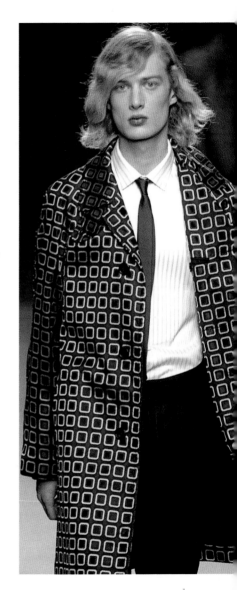

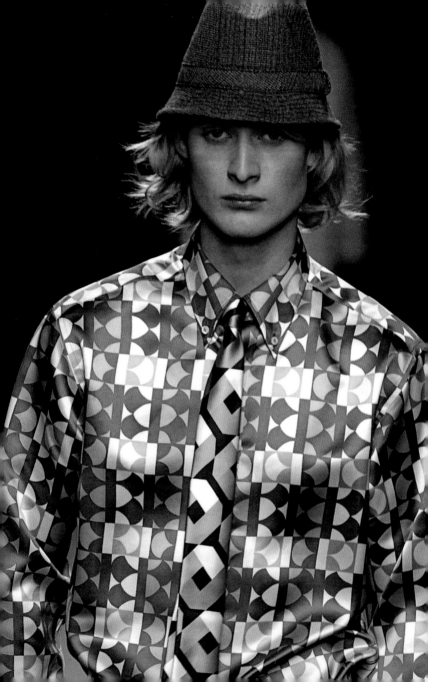

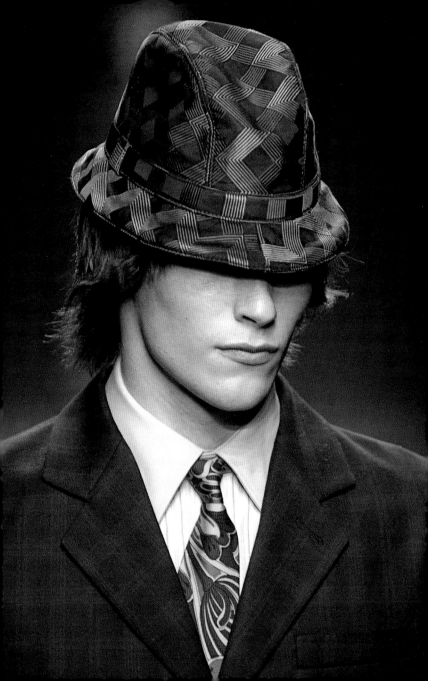

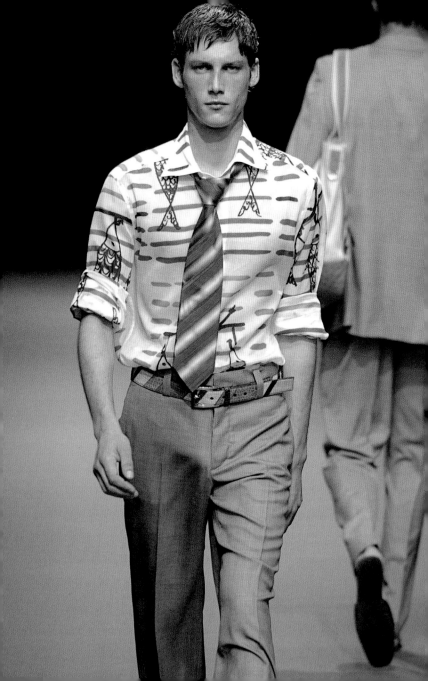

Opposite Originality is key for this smart/casual outfit that features a summery shirt with a fish motif teamed with suit trousers, a belt and tie.

Right From spring/summer 2005, this abstract printed shirt in orange, brown, white, green and yellow is worn with tailored trousers and colourful trainers (sneakers).

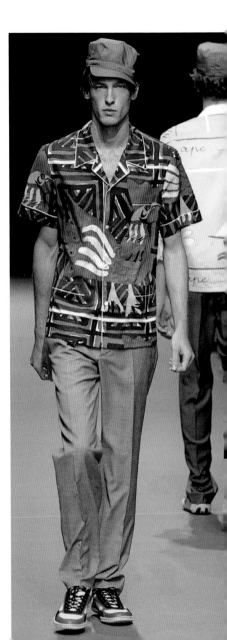

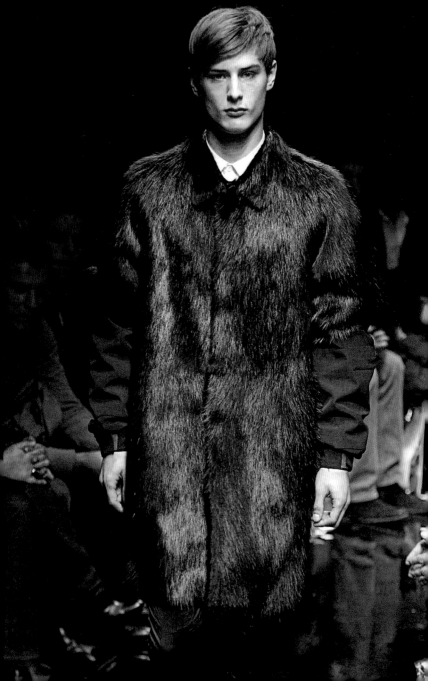

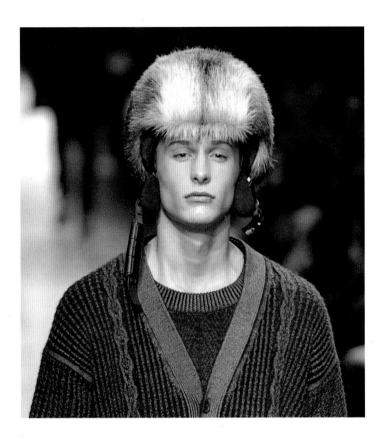

Opposite The autumn/winter 2007
Prada menswear collection explored
texture and colour in its knitwear and
outerwear. Here we see a striking
black fur coat worn over a pristine
white shirt.

Above Badger-fur-covered crash
helmets in autumn/winter 2006
lighten the show and add texture
to an otherwise classic collection.
Quilted, leather-trimmed shirts
and cashmere knitwear slung
over shoulders were standouts
from the collection.

Accessories

Accessories also break the mould of what is considered standard, not only for their design (spring/summer 2011 showed lace-ups with a compressed three-tier base of leather, espadrille and trainer-soles), but also in the way they are combined with the rest of the outfit. Suits were worn with silver trainers (spring/summer 2006) and fur-covered crash helmets (autumn/winter 2006) added a touch of humour to the show, lightening the mood.

Men's mainline accessories still retain the brand's trademark styling of confident, clean, organic lines and provide the must-haves of the season by mixing tones and textures, such as perforated leather, ostrich skin or high polish with matt finishes. The brand's approach to elegance and sophistication is often coupled with a touch of sports detailing and comfort is never compromised.

Right Accessories are an important part of the Prada Men style. Classic suiting is jazzed up with sunglasses and a fur-covered helmet.

Opposite Spring/summer 2012 was full of golf references, from shoes to flat caps. Nylon bags and leather folders provided finishing touches.

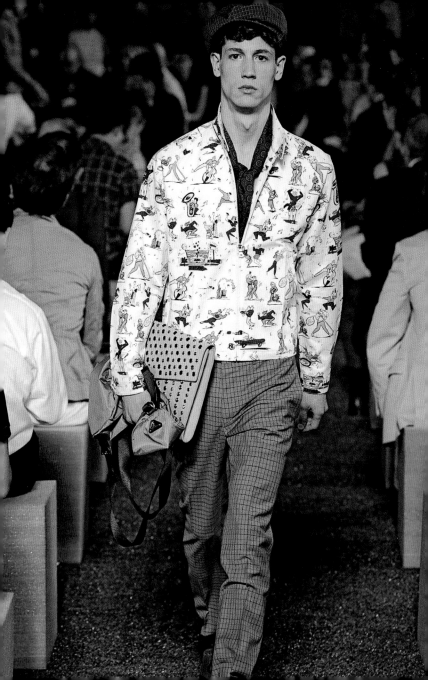

The Prada Man

The spirit of Prada menswear comes alive in the shows and campaigns. Just as in womenswear, the male models cast by the House of Prada are often not conventionally good-looking, but are chosen because they encapsulate the feel of the time. This reinforces the idea that Prada is not merely about frivolous beauty and adds depth to the narrative of the story.

In many cases models are chosen at the beginning of their careers, as if Miuccia had a sixth sense that enables her to discover the face of the moment, and they rocket them to fame soon after. The same applies to Miuccia's brilliant choice of celebrity faces – among them Tim Roth, Joaquin Phoenix and Tobey Maguire – that represent Prada's idea of modern masculinity, removing the focus from bravado or a macho image.

Opposite left This vibrant blue blazer is worn with a striped black, red and white shirt. The outfit is accessorized with sporty, wrap-around sunglasses worn around the neck.

Opposite right Glasses and sunglasses have been a key accessory in the Prada look since their launch in 2000. These wraparound glasses add a sporty element to this preppy outfit.

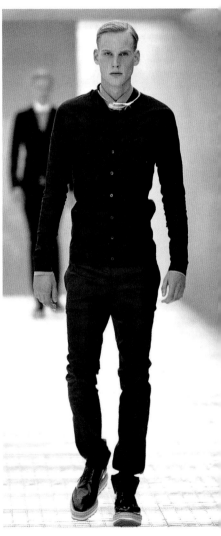

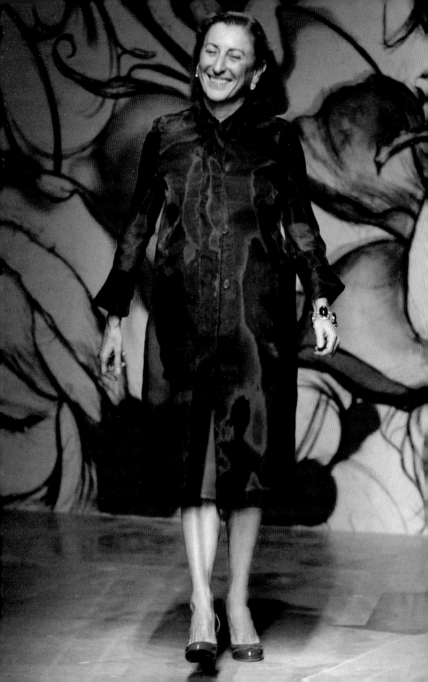

New Millennium Collections

In the run-up to the new millennium, fashion began to draw on past references and the first decade of the twenty-first century saw a return to femininity and ladylike elegance. Prada was a key player in this shift in aesthetics.

The rise of the Internet changed the pace at which the world communicated and fashion became more fluid and fast-changing. High-street retailers established themselves in the marketplace with the concept of live collections that could be designed, manufactured and sold within days. To ensure their position in the market, luxury brands highlighted their heritage and quality values. Prada, following a compelling desire for reinvention, went one step further in creating an ever-changing modern and classic image that was to become its blueprint and embodied a no-fuss functional identity.

Opposite Miuccia Prada, the woman whose vision and creative force reinvented the House of Prada, greets the audience after a fashion show in 2007.

The Ladylike Collections

Elsewhere in the fashion world, military garments, the grunge look and a return to vintage were strong influences and although Miuccia Prada incorporated some of these elements in her designs – she is a self-confessed uniform lover – the focus on exploring and reinventing the ladylike formula remained, characterized by belted shapes over pencil or full skirts, complete with high heels and the obligatory structured handbag.

Prada's spring/summer 2000 collection was launched to great applause. Presenting a refined silhouette and using a colour palette that included camel and white with accents of lilac and yellow, the collection was beautifully accessorized by high heels and handbags, showcasing the company's complete product range. Polo necks were styled with fitted skirts and warm colour combinations, together with "lips and lipstick" motif prints that ensured the austerity typifying these garments also had an edge. This clear-cut silhouette was to resurface over the seasons, redefining elegance and keeping the fashion audience on its toes, wondering what the next twist would be.

Almost a decade later, in the autumn/winter 2009, this same shape returned, but this time with an accompanying back-to-basics approach and an air of starkness that mirrored the bleak financial times. Tweed, pencil skirts and fabulous fabrics made for a winning formula that ticked all the boxes, as Prada came full circle in the quest for continuous reinvention.

Opposite left A white, fur scarf, with accents of black, worn with a fur gilet adds volume and texture to a feminine outfit.

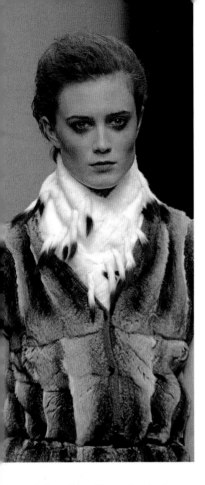

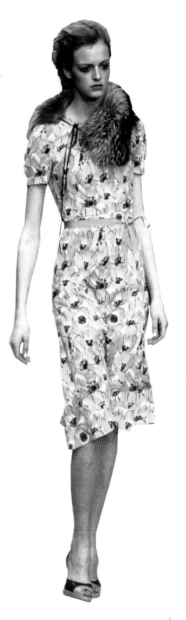

Right A fur collar, tied at the front, accessorizes this belted yellow patterned dress, which is worn with peep-toe heels, all of which evoke a 1940s flavour.

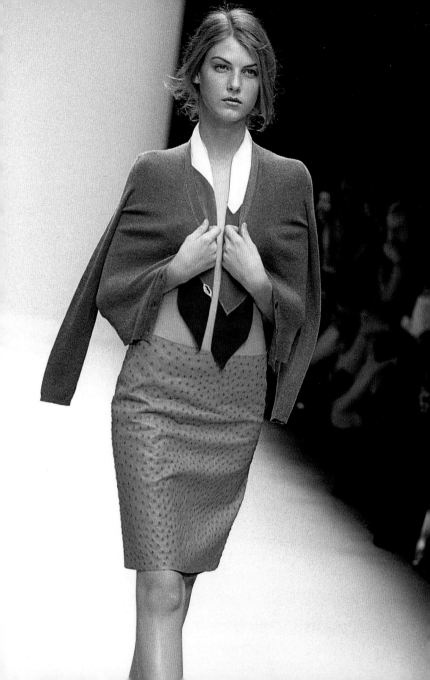

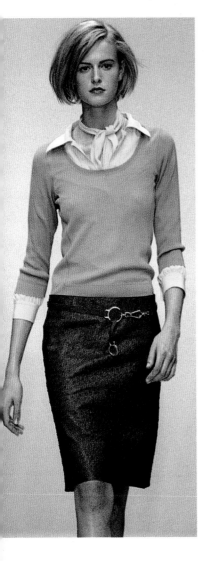

Opposite This pencil skirt, teamed with a lilac cardigan and a scarf, creates the ladylike silhouette for which Prada has become known. The spring/summer 2000 collection oozed this kind of understated, prim and polished style.

Left A camel jumper over a yellow shirt, worn with a belted brown pencil skirt, combined seamlessly in spring/summer 2000 to create a classic feminine look.

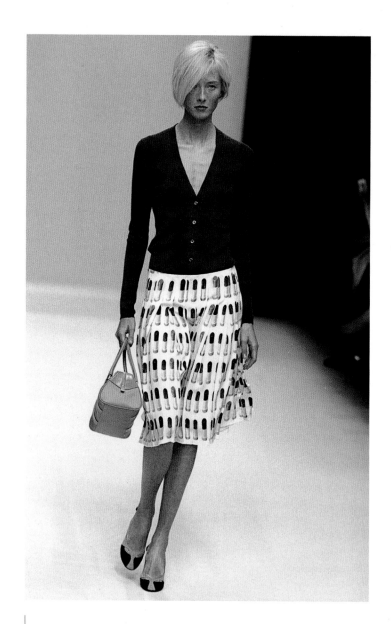

Opposite The iconic lipstick print on the fabric of this skirt was featured in the ad campaign for spring/summer 2000. Here, the skirt is worn with a fitted cardigan and matching shoes and bag.

Above and below The shoes from the spring/summer 2000 collection sported the iconic lip print and love hearts, creating a fun and feminine look.

Conceptual Collections

Another key ingredient in Prada's anthology is the conceptual aspect of the work, which reflects Miuccia's love of ideas and ability to make us question our preconceptions. It explores interesting shapes and unusual concepts, such as see-through outerwear (autumn/winter 2002), which are often fused with historical references. One of the most striking displays of intellectual expression is the autumn/winter 2004 collection, a unique show with Prada's ethos written all over it. Anchored in elegance, it combined references inspired by nineteenth-century paintings from the German artist Caspar David Friedrich, with video-game graphics. Miuccia spent hours watching video games to capture the mood of the virtual world and successfully turned this concept into wearable clothes: T-shirts with robot appliqué were worn with full skirts; coats and skirts were made from computer-generated printed fabric; and classic bags were accessorized with robot key-chains made from industrial components. In keeping with the essence of her signature elegance, the show brought together high and popular culture in a journey through the ages.

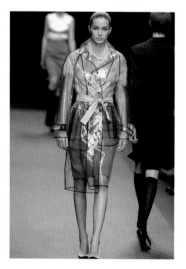

Left This conceptual, see-through mac with black piping made a statement in 2002. The raincoat becomes opaque when wet.

Opposite For autumn/winter 2004, Prada presented a collection that combined references inspired by the nineteenth-century German artist Caspar David Friedrich with video game graphics. This pencil skirt, jumper and open coat, with a high belt tied to the side and featuring an unusual print, show how the achieved look was both elegant and original.

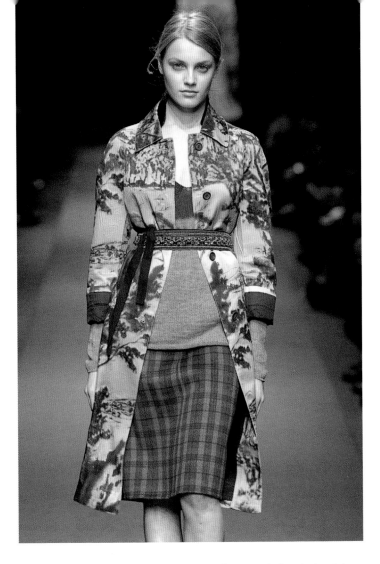

Overleaf left and right Prada
introduced some fun in autumn/
winter 2004 by accessorizing
classic bags and belts with robot
key-chains made from industrial
components. This was a great
example of past and present
coming together as one.

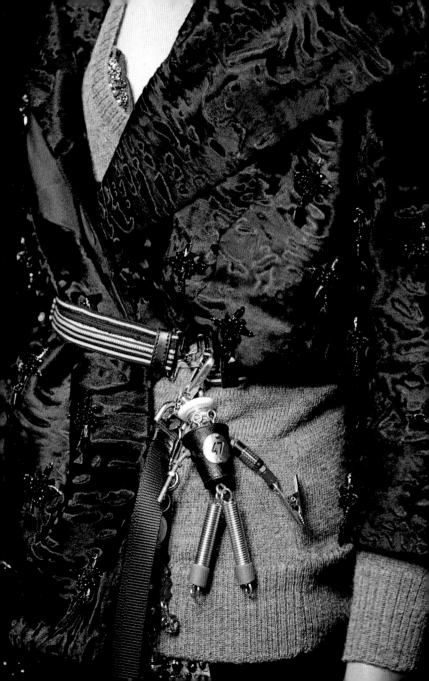

Colour Splash

Prada's pursuit of the unusual is always apparent in Miuccia's experimental colour schemes, which over the years have caused a few raised eyebrows – sometimes for being overly mute, other times too bright, or for matching colours that theoretically shouldn't go together. Even when the collections are kept fairly monochrome they usually contain dashes of unexpected colour, even if it's just the accessories. A particularly strong collection, spring/summer 2003, incorporated vibrant colours – lime green, orange and pink – in a contemporary display of Prada's much-loved 1960s shapes and accessories, with some

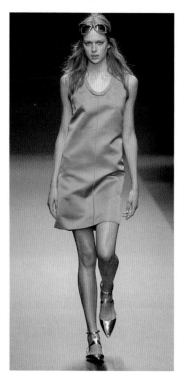

Left This sleeveless green dress encapsulates the simplicity of Miuccia's masterly lines.

Opposite left Spring/summer 2003 incorporated vibrant colours, such as this orange skirt and pink top – worn here with sunglasses to add a sports chic element to the outfit.

Opposite right The spring/summer 2005 show introduced tall, crocheted cloche hats, chain and beaded necklaces and adorned fabrics. This plain grey shirt is given a lift with a necklace of yellow, red and navy textured beads and has embellishments attached to the shirt pocket.

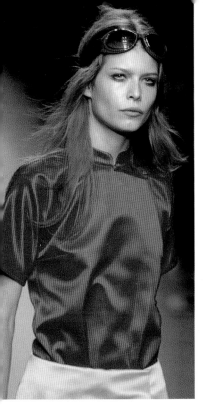
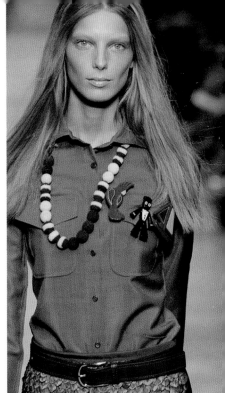

sports-chic elements thrown into the mix and flat sandals gracing the catwalk. The spring/summer 2005 show introduced bright feathers in skirts and dresses (see also page 38); also tall, crocheted cloche hats, chain or beaded necklaces and embellished fabrics. Lively short dresses, casual shoes and Caribbean influences all came together under a reggae soundtrack. More colour was seen in spring/summer 2007, when rich jewel tones shone in a feminine show with shapely lines. Here, the girls wore belted frocks in reds, purples, greens and blues with contrasting coloured turbans that were reminiscent of 1940s headdresses from the Golden Age of Hollywood.

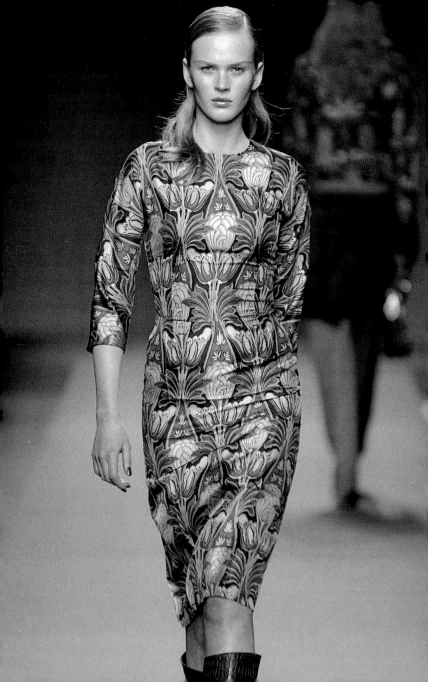

Prints and Patterns

Prada's brilliance is also reflected in Miuccia's choice of print and pattern, which sometimes includes a hint of irony – in spring/summer 1996, for example, she used 1970s-inspired retro prints (see pages 36–37). Other collections, such as autumn/winter 2003 showed sublime taste, which included spectacular William Morris prints in a wintry show that included accessories such as trilby hats and gloves.

Some of the most talked-about work to date was featured in 2008. In the spring/summer show, Miuccia collaborated with illustrator James Jean to produce a print that integrated elements of a graphic novel with surreal and romantic notions, as well as sci-fi elements. Ever evolving, yet always true to her core style, the result was a "fairy-tale" collection, where delicate silks blended with bold Art Nouveau influences. The print was used as a backdrop mural and as a prominent feature in the season's advertising campaign; it also became one of many wallpapers displayed in Epicentre stores. Afterwards, Jean and Prada collaborated in a short illustrated film, *Trembled Blossoms*, which was presented at the New York Epicenter during Fashion Week.

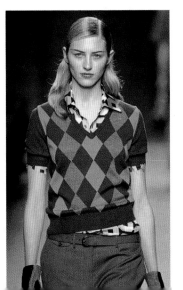

Opposite The autumn/winter collection of 2003 included this stunning, green William Morris print dress.

Left The clashing of prints is achieved beautifully in this autumn/winter 2003 ensemble. Here a classic Argyle pattern in green, grey and black is worn with a 1970s-inspired short-sleeved shirt.

New Millennium Collections **109**

Soon Prada's popularity had reached an unprecedented high, and outside the catwalk the label had come to mean much more than fashion. Indeed, it had become embedded in current popular culture. The year 1998 saw the launch of the iconic TV series *Sex and the City* (1998–2004) featuring four glamorous, fashion-loving New Yorker female friends. The main character, Carrie Bradshaw (played by Sarah Jessica Parker), was frequently dressed in Prada or seen carrying a Prada shopping bag. In 2008 *Sex and the City*, the film, was released, followed by a sequel in 2010. Another huge box-office hit acclaimed by fashionistas worldwide was *The Devil Wears Prada* (2006), a romantic comedy staring Meryl Streep and adapted from Lauren Weisberger's novel, which reinforced the label as a household name. Prada garments were used extensively in the movie and it is estimated over 40 per cent of the shoes worn by Streep in the film are by Prada.

In the music industry, urban artists not only started to wear Prada clothes – particularly rap and hip-hop stars – but they also began to "label drop" in their lyrics as a means of depicting success and status. Among them were Jay-Z ("Girl's Best Friend", 1999), Hip Hop Dub Allstars ("I Just Wanna Love You [Give It 2 Me]", 2000), Enur ("Ucci, Ucci", 2008) and Fergie ("Labels Or Love", 2008).

Opposite For the spring/summer 2008 show Prada collaborated with illustrator James Jean to produce a print for the collection. Here, a green silk dress is worn with contrasting yellow and black tights and Art Nouveau-style shoes.

Overleaf left This ethereal, lime green silk top, with matching trousers, gives the model an almost fairy-like quality as she walks down the catwalk. A waved neckline adds to the sense of fluidity of the outfit.

Overleaf right Illustrator James Jean produced a backdrop mural for the catwalk show and designed wallpaper that was displayed in the Prada Epicenter stores. Jean also created a four-minute, animated film called *Trembled Blossoms* that was shown at the New York Epicenter. A later installment featuring the same nymph-like protagonist, *Trembled Blossoms Issue 02*, was later shown at the Tokyo Epicenter. The print was used in handbags, shoes and packaging.

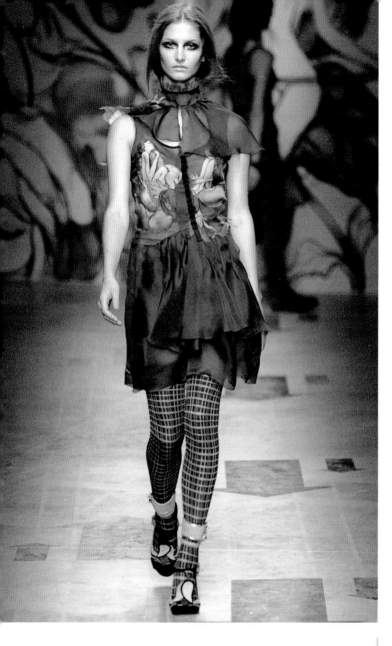

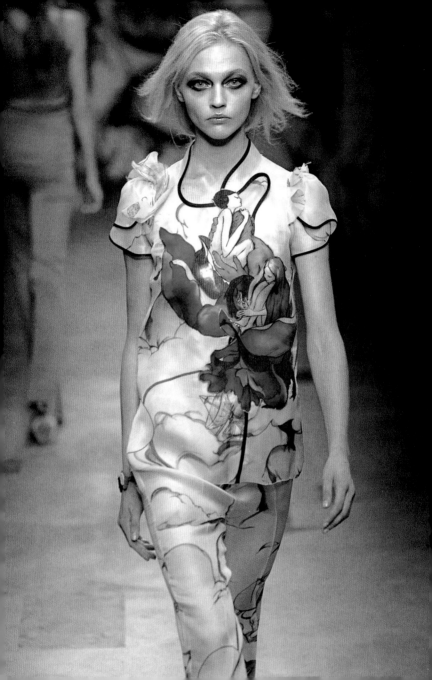

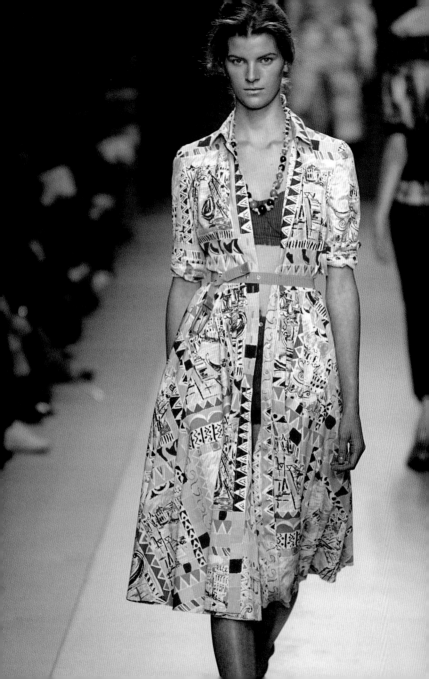

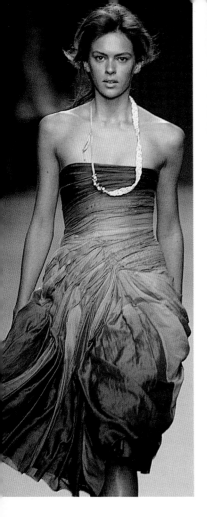

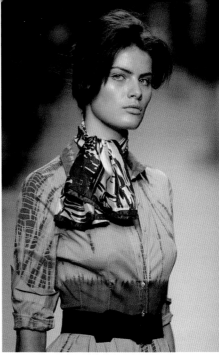

Above A brown tie-dye dress, accessorized with a black belt that emphasizes the waist and a neckerchief in a colourful print.

Opposite The spring/summer 2004 show emphasized traditional crafts, which included dip-dye and tie-dye techniques. The print on this dress, worn open and tied with a belt, has tribal influences.

Above left This breathtaking sleeveless dress, in graded shades of grey, cream and olive green, is ruffled to create texture and shape.

New Millennium Collections **115**

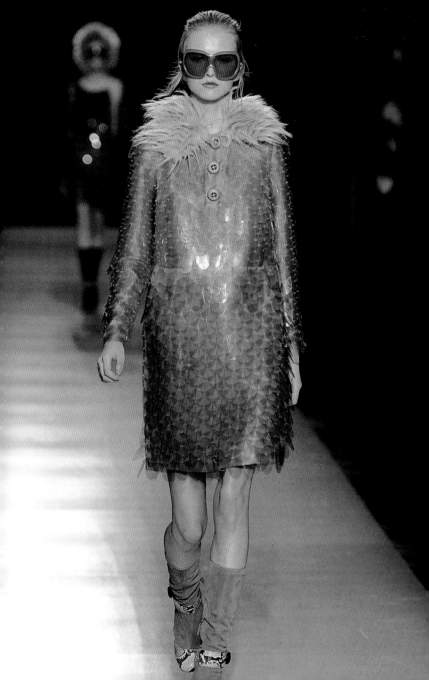

A New Decade

The Prada collections in the years since 2010 have displayed a new energy and boldness that perhaps only comes with experience. Retaining its signature style throughout, the shows have shone brighter, capturing the attention of a global audience in an unprecedented way. This success has in turn become a powerful new strength, so influential that the trends it features, from ladylike clothing to prints or faux fur, have instantly risen to the top of the fashion charts. It would almost seem that Miuccia Prada has a crystal ball telling her exactly what people want and when they want it.

"I am always researching new ideas on beauty and femininity and the way it is perceived in contemporary culture."

Miuccia Prada

Opposite Oversized sequins that look like fish scales glisten in the autumn/winter 2011 show. Oversized orange sunglasses and boots in snakeskin and suede that look like shoes worn with socks, add glamour to the look.

Overleaf left An inspired 1950s silhouette took centre stage in the autumn/winter 2010 show. This outfit contrasts two different prints and is accessorized with gloves, a handbag and bow-detail shoes that accentuate the femininity of the collection.

Overleaf right Black ruffles over the bust area of this red dress add volume and reinforce the feminine hourglass shape. Long socks and red matching shoes and knitted handbag are the perfect finishing touches.

Mad Men's Women

For autumn/winter 2010 we saw a return to the glorious femininity reminiscent of Prada's earlier collections from the start of the century. This time, however, the ladylike style was strengthened by a slightly redefined silhouette that was curvier and emphasized the bust as much as the waist. The new look also included strong, large prints with a retro air about them in stunning faded browns, blues and reds. Frills and ruffles added volume to the bust area and there were some almost fetishistic touches, such as the combination of rubber with knitwear or open-toe stilettos worn with generously thick socks. Hair was worn in a dramatic beehive with a knitted band, exposing a clear face with little make-up and accessories accentuated the ladylike theme – gloves, skinny belts with bow detailing, small or medium handbags, high heels (pointed, rounded, strappy) and cat's-eye glasses that could easily have belonged to an eccentric, 1950s, sexy secretary. It was a strong collection that reflected the popular TV series of the time *Mad Men* (2007–2015), with its feminine curves and 1950s styling. Very much designed for real women, it brought with it a sense of fun and flirtatious beauty.

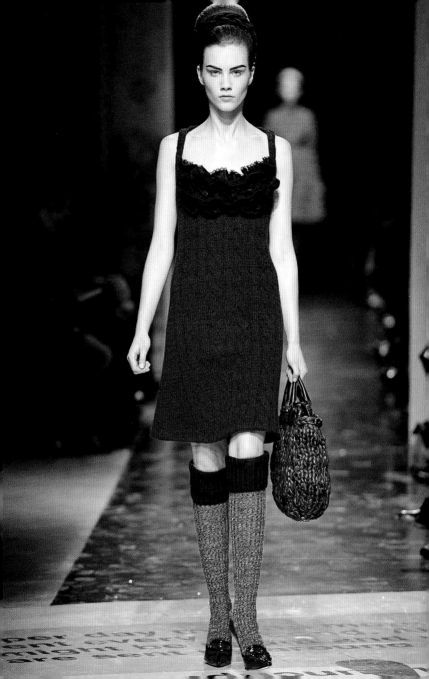

Prada Goes Bananas

The following show, spring/summer 2011, had such an impact worldwide and was so influential that it can, to a large extent, be considered responsible for some of the main trends that season: strong prints, bright colours and colour blocking. Simple lines in above-the-knee suits, separates and dresses allowed for an unparalleled burst of colour. The models' make-up featured silver eyeshadow and hair gelled in 1920s-style waves.

Plain bright orange, electric blue and emerald green frocks opened the show with a vibrant energy that was also present in a series of striped designs. These stripes were seen on oversize hats, handbags, skirts, tops, stoles, dresses and jackets – sometimes alone and at other times part of a larger, more ornate design or print. The accessories were unforgettable, their message loud and clear: from large picture hats to the intricately exquisite platform braided shoes and swirly detailed sunglasses, which have been aptly named "minimal baroque".

There was also a touch of humour running through this collection, perhaps best typified by Miuccia's use of the "banana print" (green or yellow bananas on a dark background) that introduced a tropical ease and flamboyance into the show – a joke shared by many, including *Vogue* editor-in-chief Anna Wintour, who has been spotted wearing at least three different versions. Even banana earrings were added to the collection before it hit the stores after Miuccia was seen sporting a pair on the day and they became the talk of the show.

Top With hair styled in slicked-down finger waves, feet elevated on striped espadrille wedges, and walking to a mix of tango and flamenco music, the models at the spring/summer 2011 show evoked a Latin American vibe. In keeping with this, monkey and banana prints were used on flounced Baroque-print rumba skirts and bowling shirts.

Bottom Miuccia Prada, the designer who made black nylon chic, takes a bow wearing a pair of banana earrings.

Opposite The influence of the American dancer, singer and actress Josephine Baker is impossible to ignore. In this 1927 lithograph by Paul Colin, Baker is shown performing the Danse Sauvage at the Folies Bergères, wearing a skirt made of artificial bananas. Baker's iconic performance style, voice and costumes made her hugely successful, and by 1963 she was one of the highest paid performers in the world.

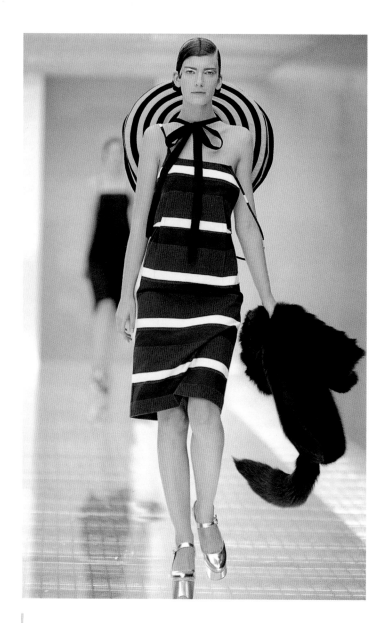

Opposite This dress, in black, white and blue stripes, paved the way for the colour mismatching and print-clashing trend that followed that season.

Above left Platform shoes take a new turn with these three-tiered soles made of fused leather, espadrille and rubber. A compact handbag completes the look.

Above right A wedge is given added height by fusing several soles together. Here, the blue rubber sole matches the classic Prada handbag.

Overleaf left This low-slung outfit is strongly influenced by 1920s flapper dresses. Its geometric design also resembles Yves Saint Laurent's colour-block Mondrian dress from 1965.

Overleaf centre Pearlescent sequins have a shimmering fish-like effect. The models held onto their handbags tightly at this show, which became a much talked-about point.

Overleaf right A belted coat becomes an extraordinary bird-like garment with the addition of gold sequin front panel and fur trim on the sleeves.

For autumn/winter 2011 the mood remained playful but more seductive, with an added injection of glamour in an exciting collection of 1960s-inspired short shapes, dropped-down waistlines from the 1920s and knee-high boots with a curved heel.

The girls looked young and innocent. Clutching their handbags tightly, they wore little make-up, with blush used both on the cheeks and on eyelids. In contrast, reptile skin featured in coats, bags, shoes and boots, some of which were particularly striking – especially the two-tone coloured boots that looked like long socks under Mary Jane shoes. Oversize resin sequins resembling fish scales glistened on the dress, adding an aquatic feel. Fur and fake fur were also explored, particularly in outerwear – which became a big trend in autumn/winter 2011. Accessories added sublime finishing touches to a futuristic image with eyewear that looked like oversize goggles and bonnets resembling swim or aviator caps with straps under the chin, in python, wool cloth and fur. Combined, these unlikely influences created a mesmerizing image of rare beauty and also set the tone for a number of new trends, including textured outerwear, 1960s shapes and shimmer.

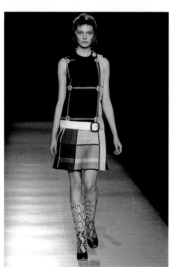
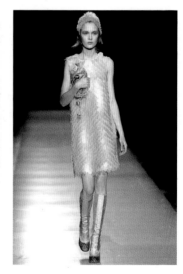

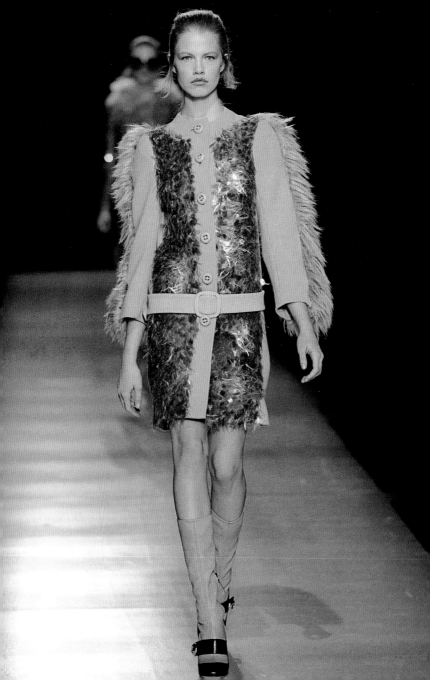

Women and Car Engines

The spring/summer 2012 show was a captivating, 1950s-inspired, candy-coloured collection titled, Women and Car Engines, with automobile references in accessories, garments and prints. Once again a new set of contradictory elements came together in Prada's trademark ladylike look, successfully portraying a retro-bourgeois style with accents of vintage. The venue was made to look like a car park or garage, with pink paint stains on the floor that might suggest a recent spray job. Cartoon-like cars made from foam provided some of the seating. Models emerged wearing natural make-up, with pale pink lipstick and side-parted hair that was loosely waved and tidy.

The colour spectrum was delightfully soft and clean, and included pastel shades such as pale pink, yellow and blue, as well as stronger hues like turquoise, bottle green, deep red or bubble-gum pink. It was a collection of dresses (many in flowing chiffon), skirts (pleated and pencil-shaped), floaty blouses and cotton tube-tops, which also featured structured, embellished coats and glamorous satin swimming costumes, panelled and shaped to enhance the hourglass figure.

The accessories that stole the show, however. Vintage-inspired earrings, bracelets and necklaces featuring an adornment of roses were reminiscent of heirlooms handed down through the generations – this collection inspired Prada to launch their first jewellery collection in 2012. In an otherwise classic look, some of the bags had studs as embellishment while others bore pictures of cars. Also in keeping with the theme, some of the shoes had cutout flames on straps and small tail-fin lights on the heel, adding a super-hero quality and strength to an otherwise sweet portrayal of elegance.

So, what will come next? We have all come to expect the unexpected from Prada, so there are sure to be more surprises in the future.

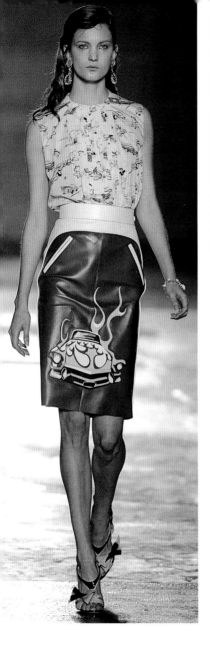

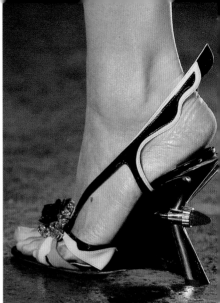

Left and above The 1950s-inspired show was all about "Women and Car Engines". The light blue top, with its car print, was worn with a leather pencil skirt with a pink Cadillac-style car on the front. The shoes from the spring/summer 2012 collection were sensational. The ones seen here had cutout flames on the side-straps, and small tailfin lights.

Overleaf The cartoon car print was used for this pastel coloured dress, which is cinched at the waist and falls just above the knee.

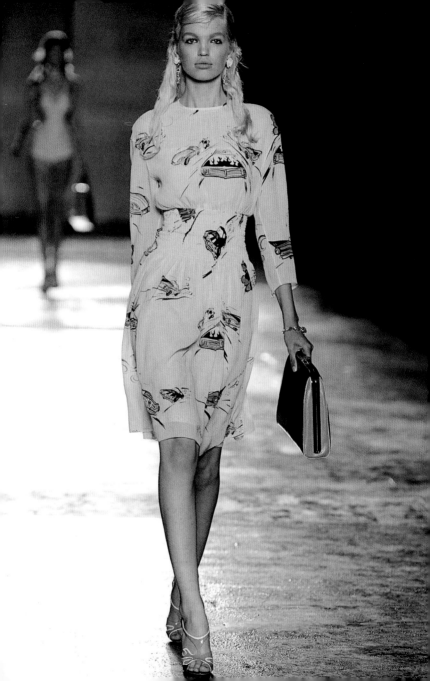

Opposites Attract

The autumn/winter 2016 collection juxtaposed themes like no other before. In a deconstruction of a traditional linear narrative (also present in the autumn/winter 2013 and spring/summer 2015 collections), this show combined a number of looks and styles that – at a glance – would appear to have been thrown together but instead, of course, had been meticulously curated one by one. The backdrop to the show was a dark, wooden set with a balcony on which a few candles flickered, evoking a faraway place and time.

The show began with tailored jackets and coats worn with corsets over them as belts, and argyle tights matched with lace-up boots. We then saw military-inspired jackets, which were at times worn with full-length feminine 1950s-style dresses in exquisitely delicate gilded silk. Then there were big tailored jackets with fur trims and embellishments on dropped sleeves, deconstructing the classic silhouette. There were also pattern-clashes worn throughout with lots of accessories layered on at once – such as necklaces, trinkets (personal diaries and keys) long knitted gloves, stark white sailor hats, belts and bags (models sometimes wearing more than one as if thrown together). Fabrics were also varied throughout the presentation: leather, fur, velvet, silk, brocade, cotton, nylon, but they all came together in a collection that seemed to embrace a number of elements or aspects of the journey that is womanhood, almost as if in a search of a woman's own identity.

In Prada's own words: "We need to understand who we are now... Maybe it's useful to look back to the different characteristic moments, difficulties, love, no love, pain, happiness, different kinds of women: sexy, boring, traveller... So this was the main concept."

The show also seemed to communicate a sense of uncertainty on a more symbolic level: the pristine white sailor caps reminiscent of World War II, and the overall image of the traveller who wears all her possessions at once, fleeing or moving on, echoing the "vagabond" woman – perhaps mirroring the general unpredictability that is felt in today's world of global politics.

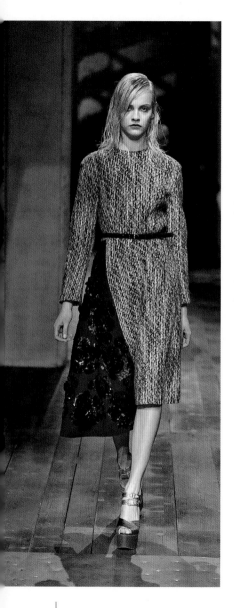

Left Autumn/winter 2013: two silhouettes, two textures, two lengths and two colours produce a unique, unmistakably Prada, asymmetric dress.

Above This two-tone sublime clutch bag from spring/summer 2015 is worn against an exquisitely delicate frayed shirt and skirt with no hemline.

Opposite Autumn/winter 2016's "vagabond" collection effortlessly combines textures, patterns, colours, accessories and styles.

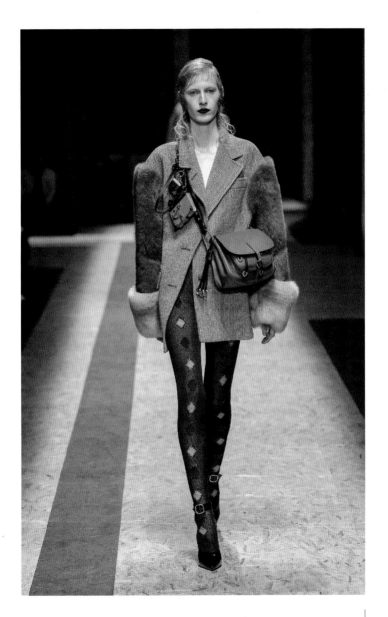

Beauty and Fragrance

Prada's launch into the cosmetics industry reinforced the lifestyle aspect of the brand, allowing it to reach out to a far wider audience and making it more accessible to the general public.

The first launch, in 2000, was Prada Beauty – a line of cosmetics that shared the label's identity in a minimalist, yet futuristic packaging. Its unique selling point was that it presented premium products in one-application blister packs that were ideal for travel. Then, in 2004, the first women's fragrance was introduced. The debut scent – created by Max and Clement Gavarry in colaboration with Carlos Benaim – has been described as a modern classic. With top notes of bergamot, orange, rose and patchouli, it carried all the beauty and simplicity associated with the Prada name and was presented in a simple, rectangular glass bottle with the lid to one side – an eye-catching design that has since been used for a number of Prada fragrances, including L'Eau Ambrée and Prada Tendre.

Opposite and above In 2000 Prada launched a beauty and skincare line. It was uniquely presented in single-application packs and the overall design of the packaging was clean, futuristic and minimal.

The first fragrance for men, launched in 2006, was a timeless, yet contemporary scent: rich, clean and characterized by a soapy smell reminiscent of an old-fashioned barber's shop. Others in the men's range include Infusion d'Homme, Infusion de Vetiver and more recently, Amber Pour Homme Intense.

Although there have been many Prada perfumes since the long-awaited first introduction, some of which have been limited editions, overall the Prada Parfums for men and women fall into two categories: the Amber fragrances and the Infusions. Combining exotic notes and essential oils, the Amber range reformulates classic ingredients used in ancient perfumery to create new, modern scents. Presented in oversize, generously thick glass bottles, the Infusions take inspiration from flowers, employing traditional techniques to distill and capture their essence in a meticulous, slow and old-fashioned process. Part of this collection are Infusion d'Iris (a light, fresh scent that evokes memories of Italy, with ingredients such as iris, orange blossom and cedar), Infusion de Fleur d'Oranger and Infusion du Tubéreuse – all creations of leading nose Daniela Andrier.

Right Prada's first women's fragrance was launched in 2004 and came in this classic rectangular glass bottle with the lid to one side. This elegant style of container has since been used for several other Prada fragrances.

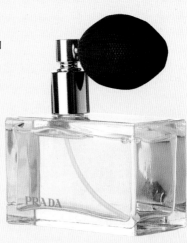

Left Prada's first men's fragrance, launched in 2006. A later addition, Infusion D'Homme (seen here) was launched in 2008. It uses the finest artisan traditions of classic perfumery to create a fresh, sensual scent.

Overleaf Prada Candy, launched in 2011, is the latest women's scent to join the Prada perfume family. Designed by perfumer Daniela Andrier, its intense, sweet, exotic scent contains notes of vanilla, caramel and white musk. French actress and model Léa Seydoux, seen here, fronts the ad campaign.

The latest addition to the Prada fragrances – also by Andrier – is Prada Candy, an eau de parfum that is sensual, intense and luxurious in a way that has become synonymous with the range. This particularly sweet scent contains notes of vanilla, caramel and white musk, and is brought to life in a fun campaign starring a beautiful young student (played by French actress Léa Seydoux), who tries to seduce her piano teacher by dancing with him spontaneously. Like the scent, the theatrical number (based on the 1930s Parisian Apache dance) is extremely passionate and dynamic. And the packaging, which merges vibrant Pop influences with classic Art Nouveau, is yet another example of the running thread of Prada's philosophy.

Prada Parfums draws on the brand's heritage in employing traditional methods and focusing on high-quality ingredients, with the attention to detail and expertise only years of hard work and passion can bring. The result is a luxury scent – modern, innovative and different – that, above all, reflects quality with an aura of glamour.

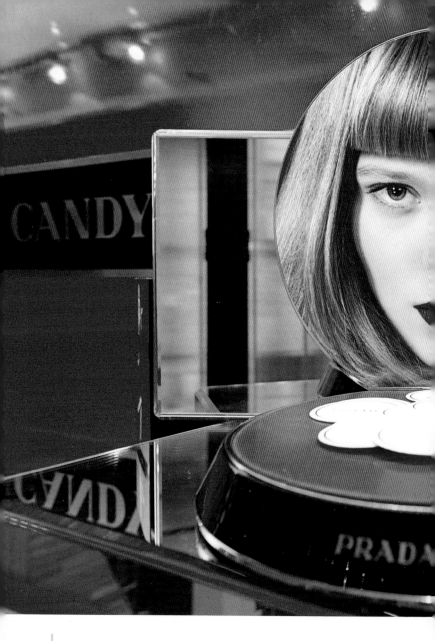

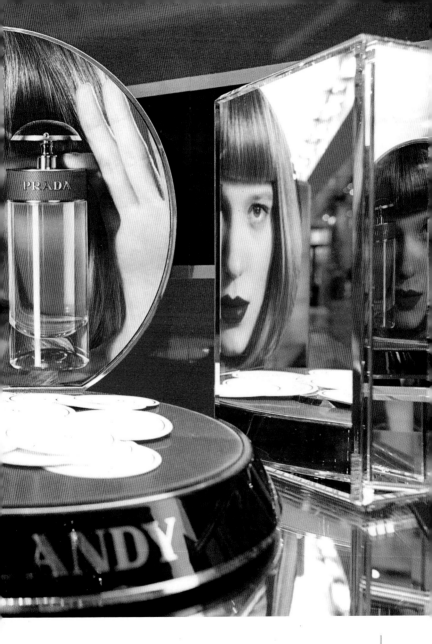

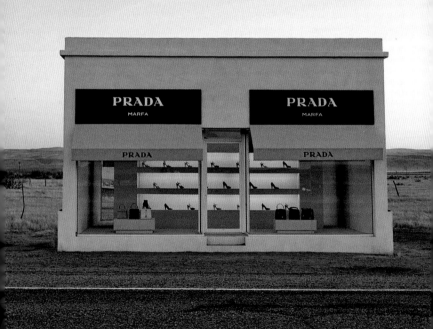

Art & Design

One might say Miuccia Prada's attitude to fashion and her way of using clothes as a form of expression makes her an artist, but the relationship between art and fashion doesn't end there. The name Prada has also come to stand for a strong involvement in, and promotion of, contemporary and avant-garde art. That interest is also seen in the meticulous attention Prada pays to designing their shopping environments.

Following their passion for art, Miuccia Prada and Patrizio Bertelli set up a non-profit foundation called Prada Milano Arte in 1993. It was located in Via Spartaco 8, an old industrial building that would provide a space for exhibitions of exciting contemporary sculpture. The first artists to show were Eliseo Mattiacci, Nino Franchina and David Smith. In 1995, curator and art critic Germano Celant joined the team, and the Foundation was restructured and renamed Fondazione Prada. Its cultural menu expanded to include projects involving photography, art, cinema, design and architecture. The first shows to be sponsored by the new foundation featured the works of Anish Kapoor, Michael Heizer, Louise Bourgeois, Dan Flavin and Walter De Maria. Over time, the foundation has supported a wealth of diverse artists, from Marc Quinn and Sam Taylor-Wood to actor Steve McQueen. With astonishing energy, it has developed and grown, hosting major exhibitions and projects of contemporary art.

In 2008, Prada and Bertelli commissioned the OMA – the think tank of the Office for Metropolitan Architecture – to create a permanent "home" for their art in an early industrial site south of Milan, that included buildings that dated back to 1910. Unveiled in 2015, the headquarters designed by architect Reem Koolhaas are yet another living

Opposite A Prada store art installation, situated at the side of deserted Route 90 in Marfa, Texas. A permanent sculpture by the artists Michael Elmgreen and Ingar Dragset, it was designed to slowly decompose into a natural landscape. Sadly, three days after the sculpture was completed, vandals graffitied the exterior, and broke into the building stealing handbags and shoes.

example of the Prada ethos of fusing old and new in perfect harmony. Modern and, no doubt, ground-breaking constructions, including a 10-storey museum tower, coexist with seven existing restored structures, among them laboratories, brewing silos, warehouses and a large courtyard. This new space is used as a complex to accommodate a series of diverse disciplines ranging from cinema and philosophy to design, fashion and performance art. It also houses works from the permanent collection as well as Prada's archives and those of its Luna Rossa team.

In May 2011, the Fondazione found a new space to showcase its art, this time in Venice's Ca' Corner della Regina – a magnificent baroque palazzo on the Grand Canal, built in 1724 by architect Domenico Rossi. At the time of writing, the palace is being restored by the Fondazione and features a semipermanent exhibition of works from its collection, including pieces by Anish Kapoor, Damien Hirst and Louise Bourgeois.

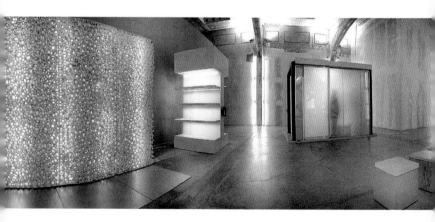

Right and below A panoramic view of the Fondazione Prada, showcasing modern design in architecture and furniture. The resin sponge wall (right) is one of the features of the Los Angeles Epicenter.

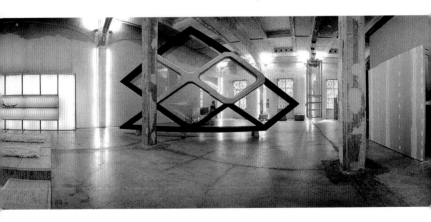

Below In a series of photographic works, Andreas Gursky explores the relationship between art and high consumer culture. Here, the *Prada I,* 1996 depicts the aspirational interior of a Prada Green store with it's pale pink floor, muted green walls and meticulously precise minimal display.

Andreas Gursky, *Prada I,* 1996.
127 x 220 x 6,2 cm.

Although it is important to note that fashion and art are kept very separate in the Prada empire, there is of course a strong common denominator to connect them, creating an almost symbiotic relationship: Miuccia Prada herself. Inevitably, both areas reference each other as well as outside influences. The results are often visible on the catwalk. Sometimes they are literal, other times presented with a touch of irony, but always part of an ongoing search: challenging, exploring and deconstructing our preconceptions of beauty. Prada's unusual – even "ugly" at times – colour combinations, interesting textures used out of context, uncomfortable or unusual themes, are all elements that provoke a reaction and make us consider our aesthetic "comfort zone".

Below An art installation by French-
American sculptor and artist Louise
Bourgeois. *Cell (Clothes)* was a walk-
in installation, the size of a small
room, that was exhibited in Prada's
Ca' Corner della Regina. Bourgeois
was one of the first artists to be
exhibited by the Fondazione Prada.

Louise Bourgeois, CELL (CLOTHES), 1996.
Wood, glass, fabric, rubber and mixed media,
210.8 x 441.9 x 365.7 cm. Photo: Attilio Maranzano

Art in the Shopping Experience

The foundation also originated the concept and construction of the Prada Epicenters, a series of extraordinary buildings that transcended the traditional use of a store and doubled up as exhibition spaces. From the beginning, the shopping experience has been carefully explored by Prada, their retail venues forming a seamless extension of the brand's philosophy. Despite its global expansion, the company remains unique in its approach to the retail experience. All of its stores offer a luxurious and exclusive environment, together with a level of personal customer service that echoes the intimacy of the original Fratelli Prada shop. In a quest to avoid global homogenization, and in keeping with their philosophy, Prada has developed two types of store: the more conventional "Green Stores" – characterized by iconic pale green walls and simple décor – and the Prada Epicenters, which are conceptual in their architecture, technology and use of space. Each new Epicenter presents an opportunity to break with any preconceptions that might dilute the label's innovative spirit through repetition.

The Prada Epicenters, described by architect Rem Koolhaas of the OMA partnership as "conceptual windows", surpass the traditional shopping experience, merging unconventionally with artistic events such as exhibitions, concerts and film screenings. In 2001 Koolhaas designed the first Epicenter store in Soho, New York. Previously part of the Guggenheim Museum, the building explores the spatial relationship between customer and product to offer new ways of shopping. The way the space is used is reminiscent of a contemporary art gallery, with interactive, changeable features such as its northern wall that connects Broadway and Mercer Street, which becomes a regularly updated mural of Prada wallpaper. Among the groundbreaking technology in this store are glass doors in the changing rooms that become opaque at the touch of a button, "magic mirrors", allowing customers to view themselves moving in slow motion from all angles and a state-of-the-art wireless device enabling staff to access customer data and vast amounts of product information, including sketches and catwalk video-clips. These can instantly be projected for the customer to view on one of the many in-store screens.

Above The first Prada Epicenter,
which opened in New York in 2001.
The space, the former Soho branch of
the Guggenheim Museum, takes up
an entire block and includes unique
features such as "the wave" staircase,
a concave shape that runs the length
of the store, and a long wall covered
in specially designed wallpaper.

Overleaf Prada Epicenters surpass
the shopping experience and
become spaces for multifaceted
art expression, such as these
female silhouettes featured in
the New York Epicenter in 2008.

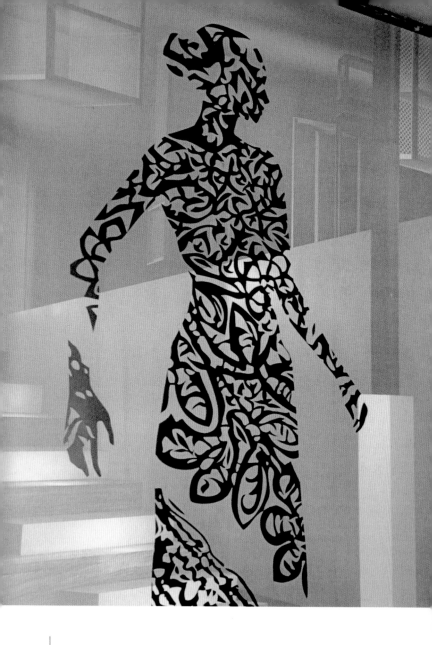

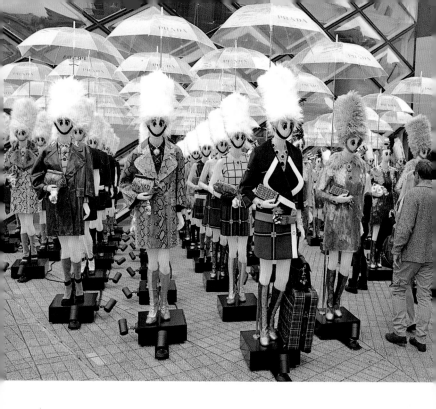

Above Prada's "Fashion's Night Out" theatrical display that took place on 5 November 2011 outside the Tokyo Epicenter. The mannequins wore clothes from the autumn/winter 2011 collection.

Opposite Swiss architects Herzog & de Meuron built Prada's Tokyo Epicenter, located in the Aoyama district, in 2003. Glass panels create a futuristic, yet organic-looking, building.

Built in 2003 by the Swiss architects Herzog & de Meuron, Prada's Tokyo Epicenter is set in the Aoyama district. This six-storey glass building, now iconic for its modern, organic and futuristic design, is made up of diamond-shaped glass panes that create an optical illusion of movement as one walks through the store, with its freestanding floor racks and fibreglass display tables. The building is at its most impressive at night, when illuminated.

In 2004, the Prada Tokyo Epicenter hosted one of the Fondazione's best-known exhibits, "Waist Down" – an exhibition of Miuccia Prada skirts from 1988 to the present day. Skirts have featured in Prada's collections season after season: this show is a rich and colourful visual synopsis, where some skirts are displayed spinning and others swishing. It's a retrospective of the art of haute couture in a journey that displays Miuccia's expression throughout, encapsulating her spirit and creative energy.

"Waist Down" moved to the New York and Los Angeles Epicenters in 2006 and 2009, and from there to Seoul – to the new Prada Transformer, a contemporary structure specifically designed for the exhibition, that was built in the grounds of the sixteenth-century Gyeonghuigung Palace (the Palace of Serene Harmony).

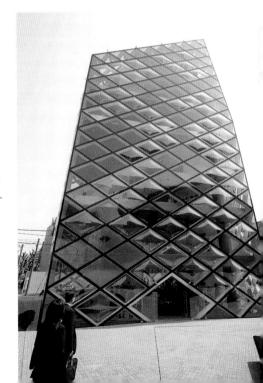

A third Prada Epicenter, built by OMA on Rodeo Drive, Los Angeles in 2004, is characterized by a single slab of aluminium above a minimalist entrance with no traditional shop front. The three-storey venue displays some of its merchandise in large underground cones and has an open ceiling with a skylight. Some features, such as the changing wallpaper displays, link it to the New York Epicenter, while a black-and-white marble floor refers back to the original Fratelli Prada Milan shop.

Above The "Waist Down" exhibition, after it had moved to the Los Angeles Epicenter in 2006. The individual skirts were displayed on metal frames.

Opposite top In another image from LA "Waist Down" exhibition, the cutouts of the model's outfits form a dramatic display in the store.

Opposite below A patterned skirt from the spring/summer 2004 collection on show, encased individually on a flat surface, as part of the "Waist Down" exhibition in Beverly Hills.

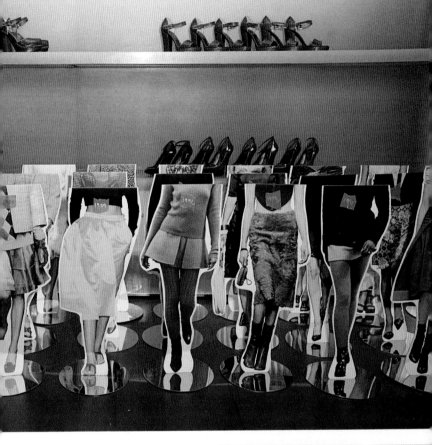

Overleaf As always with Prada, the soul of the brand is echoed throughout. In the Beverly Hills Epicenter, elements of the original Fratelli Prada store in Milan – a black and white tiled marble floor and a selection of luggage – are present, reinforcing the company's strong heritage.

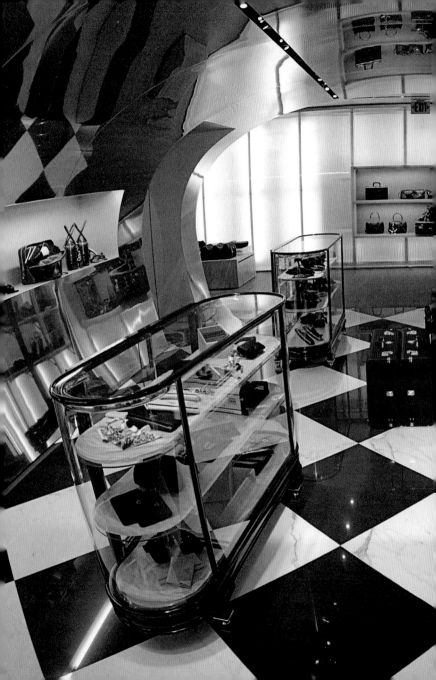

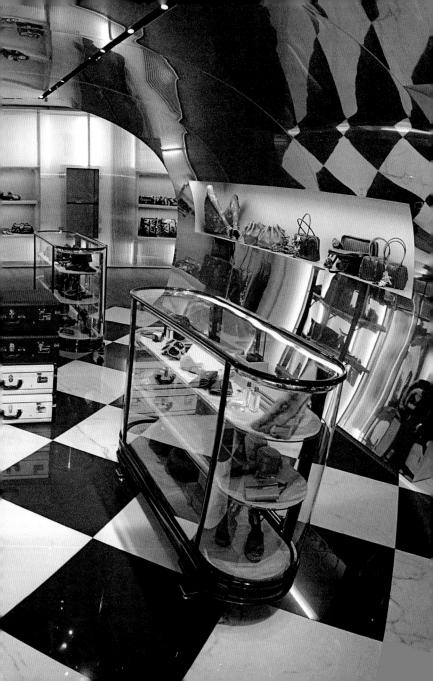

Resources

Further Reading

Angeletti, Norberto, and Oliva, Alberto, *In Vogue : The Illustrated History of the World's Most Famous Fashion Magazine*, Rizzoli, 2006

Baudot, François, *A Century of Fashion*, Thames and Hudson, 1999

Ewing, Elizabeth, *History of Twentieth Century Fashion*, Batsford, 2001

Fogg, Marnie, *The Fashion Design Directory: An A–Z of the Worlds Most Influential Designers and Labels*, Thames and Hudson, 2011

McDowell, Colin, *Fashion Today*, Phaidon, 2000

Mendes, Valerie, and de la Haye, Amy, *20th Century Fashion*, Thames and Hudson, 1999

O'Hara Callan, Georgina, *The Thames and Hudson Dictionary of Fashion and Fashion Designers*, Thames and Hudson, 1998

Polan, Brenda, and Tredre, Roger, *The Great Fashion Designers*, Berg, 2009

Prada, Miuccia, and Bertelli, Patrizio, *Prada*, Progetto Prada Arte, 2009

Collections

Due to the fragility and sensitivity to light, many collections are rotating or on view through special exhibition only. Please see the websites for further information.

The Metropolitan Museum of Art
The Costume Institute
1000 Fifth Avenue
New York, New York 10028-0198, USA
www.metmuseum.org
The Victoria & Albert Museum
Fashion: Level 1
Cromwell Road
London SW7 2RL, UK
www.vam.ac.uk

Prada Exhibition Spaces

Fondazione Prada
Via Fogazarro 36
20135 Milan, Italy

Fondazione Prada (Venice)
Ca Corner della Regina, Santa Croce 2215
30135 Venice, Italy
www.fondazioneprada.org

Prada Transformer
Gyeonghuigung Palace Garden
1-126 Sinmunno 2ga
Jongno-gu, Seoul, Korea
www.prada-transformer.com

Prada Epicenters

Prada Epicenter Broadway
575 Broadway, New York, NY 10012 USA

Prada Post Street
201 Post Street, San Francisco, CA 94108 USA

Prada Epicenter Rodeo Drive
343 North Rodeo Drive, Beverly Hills, Los Angeles, CA 90210 USA

Prada Aoyama
Minato-Ku, Tokyo 107-0062, Japan

Prada
Casa 1/B La Passeggiata, 07020 Porto Cervo, Italy

Index

Page numbers in *italic* refer
to illustration captions.
Abbreviations S/S and A/W
refer to spring/summer and
autumn/winter collections.